Juneau Projects

The black moss

IKON **GLYNN VIVIAN ART GALLERY**

Contents

Texts

Works

Foreword

Jonathan Watkins, Director, Ikon
Karen MacKinnon, Exhibitions Curator,
Glynn Vivian Art Gallery

Richard Strauss' 'Metamorphosen' is one of the most romantic pieces of music ever written. It mourns the loss of something that seemed so certain, a comforting set of values, a religious belief in art. In 'Walkman/Lake', a video by Ben Sadler and Philip Duckworth, also known as Juneau Projects, we watch a man row a dinghy into the middle of a lake and lower a cassette tape player overboard. The music it plays, 'Metamorphosen', is the soundtrack, distorted as water seeps into the mechanism, short-circuiting electronic systems as it becomes increasingly submerged in dysfunction. The music stops in the end.

'Walkman/Lake' is a work at the heart of Juneau Projects' exhibition at Ikon. It is tragic, funny, personal, too much and very knowing. It is the documentation of a strange act in rural circumstances, a gesture that raises all sorts of questions about the kinds of technology we take for granted in the metropolis. It is one of a number of poignant stories interwoven here, conflations of fact and fiction, stories of familiar and imaginary places, tales of remarkable men (and women), stories about brave new worlds that collide with unavoidable truths. We are entranced by narratives that include us easily, but not without idiosyncrasy.

Inclusivity is a remarkable feature of this project and in this vein there are many individuals and organisations to acknowledge. The Henry Moore Foundation, Arts Council England National Touring Programme have provided invaluable support especially for the production of new work, exhibition tour and this publication. Another opportunity for Ikon and Glynn Vivian to work together is especially appreciated. Through the Creative Partnerships Scheme a number of children contributed to 'I'm going to antler you', in a wonderful collaboration with Juneau Projects.

One day that pinging sound in the sky will end

Nigel Prince

You awake in a forest. The evening sun is dappling through the branches of the bone-white silver birches that surround you. They have small purple heart-shaped leaves, which are so dark they appear almost black in the evening light. You are lying on your back on the mossy floor. Small colourful fungi protrude from the moss and fallen leaves. You look up into the branches and glimpse a russet coloured wood pigeon with white markings. The markings seem to be gathered around its head and face in a peculiar way; the brown plumage is predominant around eyes and beak with large areas of white on the head and cheeks. It looks as though the markings are describing a human skull on the birds head, but before you can be sure the pigeon flies off. You are left alone in the glade pondering what seems to be a strange and grim portent. Slowly you get to your feet and pick up your bag.

You stand momentarily considering which direction you should take. Somewhere in the distance you hear a strange and foreboding sound. It is a kind of pinging noise which seems at once natural and unearthly – the sound of an implacable force probing and prodding at the world for an inscrutable intention.

Which direction will you go now?

Opening text, Juneau Projects, 'Beneath the floorboards of the forest, empty space', 2006

On a journey through a Midlands landscape we pass by a yard teeming with redundant electrical white goods. At once a towering slag heap redolent of this former industrial and mining landscape, it pays testimony to the inability to recycle efficiently. Moreover this mountain of fridges and freezers speaks of rapid turnover, of our love-hate relationship with consumer items. On the periphery of the conurbation, where

bramble and rosebay willow herb wilderness evidences nature's reclamation of tumbledown warehouses, this hinterland is the conceptual home to Juneau Projects, the collaborative practice of artists Philip Duckworth and Ben Sadler.

They have travelled past this graveyard for consumer items on many occasions. It is the place in the 'Black Country' that has now become the wasteland alluded to as the end zone for the final level of their most recent work, 'Beneath the floorboards of the forest, empty space' (2006), a text-based computer game presented on a series of hobbyist landscaped work stations placed amidst a garden of chard and ornamental thistle. For this work Juneau Projects resurrected an Atari typeface to visualise written passages describing a series of interlocking environments gradually moving from the countryside to the city. Users also have the option to listen to the texts via the inbuilt computerised speech of the Windows software reader, a further conflation of the 'natural' and man-made via technological advances.

From a forest with opportunities to visit other lands, to an island via a raft, tunnelling onward to the mainland of concrete structures reminiscent of inner-city ring roads and a fog-bound 'Spaghetti Junction', users navigate a fictional narrative and landscape akin to the actual installation and city in which they sit. Various objects, images and exaggerated characters relating to earlier work, the specific location of their childhood and memorised events and people, unfold as an elliptical narrative. Writing is often used as an organising structure, in both the planning and execution of projects, and from which springs the articulation of their ongoing preoccupations. This new work relates to their adoption of a radio play structure that formed the centrepiece of a recent installation 'Driving off the spleen' (2004), in creating a heightened storyline from a series of imagined episodes. Juneau Projects played out the scenarios across an arduous Lake District journey and presented a multimedia work where various sculptural pieces represented the characters encountered on their travels. A spoken soundtrack played through headphones and ephemera, video documentation of performances, and customised clothing, all contributed to create a fantastical

narrative of alienation in a foreign territory. Various tales were related via an antlered listening-post at the gallery entrance, while objects and large-scale photographic works embodied the characters of the story. Grappling with nature, technology and the haunting individuals they met, their journey was recounted in horrific detail. A strange hooded and anorak-clothed figure, 'Small Hands Paul', was represented by his jacket, smothered in the kind of badges proclaiming his celebration of any agenda going. His poetry spoke of all the beauty and heartbreak of the lakes reflected through the bottom of a beer glass. Lakeside, the bald-headed 'Former Professional' poured out his frustration to anyone who would listen, and the landscape painter Meg seemingly entertained the powers of darkness from her quasi-shrine, like some scenic element from 'The Wicker Man'. A crash helmet painted with the picturesque landscape through which he travelled, stood alongside the pictured, solitary figure of the 'Man of Speed'.

Within the gaming format of 'Beneath the floorboards of the forest, empty space', users encounter various network points in the floorboards that make up the theatrical ground, and during their journey are invited to collect computer parts – a wooden keyboard, a 'mouse' made of fur and bones – fashioned from natural elements. Haunted by a distant 'pinging' in the sky, we are presented with opportunities to connect, to attain a perfect resolution by achieving the implied utopian impulse – a world where nature is at one with the man-made.

While finding ourselves increasingly reliant and in love with gadgetry, paradoxically our expectations of an efficient, time-saving future are often dashed. And while we pass through the non-spaces which for many make up a familiar urban environment, commuters make use of this new-found free-time by engaging with their latest technological purchase. There is often a smell of apple in the air. Not just any fruit but a crisp one, its flesh the creamy white translucency of just picked freshness. The association of cutting edge portable technology with the epitome of a most natural and knowingly innocent healthy product provides the core for the consideration of the subject and medium of Juneau Projects production.

Their practice is rooted within the Romantic tradition, in which artists developed notions of the sublime whereby nature inspires feelings of awe and terror. For Juneau Projects, their ambivalence toward both natural and man-made worlds is made tangible in many works spilling out into a demonstration of technological frustration foiled by a fear of nature. This collision has potency within our contemporary culture at a time when dislocations between our experiences are becoming ever evident, be they the misunderstandings and conflict between the populations of cities and the countryside, or an increasingly mediated engagement through theme parks and nature trails. In the deepest of woodland when your mobile phone has no signal, it has little functional use becoming just a simple piece of plastic, a fish out of water.

These continuing preoccupations are echoed in video and performance works involving items that have the means to poignantly broadcast their own demise at the hands of Duckworth and Sadler. Examples include 'Stalker' (2001), where the artists used a marksman, usually employed to maintain the balance of deer in the wood, to hunt down a tripod-mounted video camera hidden in the depths of Grizedale Forest. As the video unfolds, the 'stalker' comes into view, takes aim and fires at the camera, the footage slowly degenerating into scrambled black nothingness as the machine records its own death. This is typical of a number of early works employing consumer objects such as mobile phones, CD walkmans, computers, televisions and cassette tape machines, all of which find their way into becoming vehicles for an examination of our alienation from the things that populate our lives.

Often there is a performative element to their work, be it a recorded action or documentation of a process as well as live performance. The video 'A rich future is still ours' (2002), visually and aurally shows the destruction created as successive sheets of paper are fed through a shredder with microphones attached; a performance 'I am swimming through pools of cool water' (2003) involves one mobile phone calling another. As the 'conversation' evolves, a blowtorch is used to set fire to the phone making the call and the receiver transmits its sizzling destruction. Such experimentation and

the often utopian language of their titles further connect Juneau Projects to Romanticism and so the idea of a destructive urge is utilised creatively. 'Walkman/Lake' (2001) depicts a man in a rubber dinghy rowing purposefully into the middle of Coniston Water in the Lake District. Set against the backdrop of picturesque mountains and trees, he lowers a cassette recorder playing Richard Strauss' 'Metamorphosen' into the water as the distorted sounds evidence its failing attempts to continue to play. Such a complex work articulates the collision of the chocolate box location in the landscape, with a mass-produced version of a piece of classical music representing ideas of a rural idyll and that of a contemporary symbol of freedom.

Throughout 2002–3, Juneau Projects embarked on a transitional time in their practice, or as they described it, a period like "a weird Karmic balance … as on one hand we took things out of the world like fax machines and TVs, but on the other we put things back like kids on CDs." This sea change, in which they went against their earlier dictum of not adding to the world, opened up the potential for them to articulate the conflict and misrepresentations thus far elaborated into more complex installations enlarging the narrative potential of their work. One of the first pieces to engage with this was 'Ban this', presented as part of the Grizedale touring 'Roadshow' project, whereby kids were given the opportunity to write and record their own lyrics over the top of pre-recorded soundtracks. Each participant was videoed making their song and given a free CD to take away. The project was later taken a step further as a live performance by Juneau Projects themselves at the Sunflower Lounge, in Birmingham, a bar operating as an alternative venue, where they remixed the tracks, lifted out the vocals and played them to a bemused audience. By making connections between the immediacy of kids effortlessly creating something new through the enabling power of simple equipment and the wonder of technology as it 'speaks' at the point of destruction, Juneau Projects set out in a new direction, demonstrating genuinely complex relationships of compelling ambivalence towards both their subject and medium.

Whilst in New York for the exhibition 'Romantic Detachment' in 2004, the artists planned to collaborate with US rock band

Flaming Fire, but for one reason or another, this failed to materialise. Based on the idea of recreating an event that never happened 'I'm going to antler you' (2006) suggests what this collaboration might have involved. Through a series of workshops two groups of children designed and sourced materials for costumes, logos and an overall 'look' in putting bands together, culminating in a series of final sessions where they became the opposing fabricated groups and produced photographic work of themselves in costume. Each formed their own collective identity with combinations of various individual characters.

The first group named themselves the embers and, growing from previous work with Juneau Projects ('Heart of an owl', 2005), adopted a series of logos using animal imagery appliquéd on to the back of white-lined orange outfits. That these designs incorporated an embroidered stylisation courtesy of Adobe Photoshop, adds a further layer of technological manipulation of 'the real', while recalling the Nudie suits worn by Country and Western singers subverted with true affection by Gram Parsons when a member of the Flying Burrito Brothers. For the embers, stylised flames sprout along sleeves while warring squirrels or fighting stag beetles slug it out on their backs. In contrast, the second group ebony angels followed a more urban, rock 'n' roll route of hoodies, jeans and T-shirts printed with quasi-heraldic emblems incorporating religious and animal head iconography reminiscent of the stuffed trophies adorning walls in a baronial hall. Alongside the photographs and costumes, Juneau Projects present musical equipment – drum kits, guitars and amps – all painted in lush picturesque landscapes as with the motorcycle helmet of the 'Man of Speed' from 2004. Emanating from these items in surround sound, are backing tracks written by Juneau Projects with self-composed lyrics performed by the children who also occasionally add extra instrumentation. Individual components from the recorded songs play when triggered by motion sensors, so the drum sound is broadcast from that equipment, vocals from a PA and so on, until the whole song is formed. Collectively this installation builds on previous works such as 'Stag becomes Eagle' (2005)where working in collaboration with community groups, cub scouts, teenage bands, soul legend Lee Fields, or highland warriors

they have created projects, outcomes including audio CDs, radio broadcasts, magazine publications, new typefaces for graphic design, and an on-line record label.

Installations have also incorporated actual performances, often unintentionally comic, acknowledging the pathos inherent in their subjects. Brought up in a culture more familiar with Brando's version of Kurtz depicted in Ford Coppola's 'Apocalypse Now' than Conrad's 'Heart of Darkness', Juneau Projects nonetheless share something with the metaphorical and existential tone of the latter. Here, 'Darkness' is the inability to see, but as a description of the human condition it implies that a failing to see or understand another, means a failure to establish any sort of sympathetic communion. And so for Juneau Projects the shortfall between our relationship with technology and its place in the natural world becomes manifest, as do our encounters with the characters who occupy the dystopian narratives of their more recent works.

'Motherf⚡king nature' (2004) at The Showroom in London was the first point in which Juneau Projects brought together earlier process-led video works with live performance and sculptural objects. Moreover, it was an opportunity to organise a constructed world, articulated as a journey populated by three main characters – 'The mush', 'The don' and 'The kingpin'. Encounters with these figures intermingled with other works in the log strewn environment such as 'The beauty royale', a video showing the artists feeding lengths of dowel with microphones attached into a chipper, or 'Good morning captain', where printouts were presented, the results of dragging a scanner along a forest floor at night. There is a direct, almost optimistic dumbness, or rather a free-spirited exuberance, in these works torturing machinery to see what might be achieved. The playful irreverence, with which Juneau Projects set to making their work, is offset against the acknowledged irony in utilising the very things they destroy to realise the projects. The uneasy reliance between man and machines is elaborated further by the pictured characters – on a TV set painted with an idyllic pastoral scene, a computer generated eagle loops from the tattooed chest of 'The mush' and intense lightening bolts from a Tesla coil transformer spark from the fingertips of 'The don'. Perhaps the most

telling element of this installation, simultaneously amusing and poignant, is 'The kingpin'. Adrift in a sea of malfunctioning equipment, presented on a monitor under the floorboards and surrounded by foliage, his unease is palpable. The figure looms from the screen, mumbling unintelligibly, at odds with the ever-changing world around him.

Parallels to these characters and their predicament can be drawn to the figure of Ishmael in Melville's 'Moby Dick', for whom the white whale is horrible because it represents the unnatural and threatening. All such creatures that inhabit extreme environments exude an aura of mystery and inaccessibility, and for the whale hidden underwater read the forest and its inhabitants. No one knows where they go, what they do or how they might appear. For Duckworth and Sadler, this impossibility of examining anything in its entirety, only the surfaces of objects and environments, expresses their ambivalence – a simultaneous awe and frustration with both technology and the natural world. This motif can be seen to represent the larger problem of the limitations of human knowledge; we are not all-seeing, only acquiring knowledge and understanding about the fraction of entities – individuals, objects and environments – to which we have access. And as progress marches on, many things wait to be discovered, to be examined and understood. One day that pinging sound in the sky will end.

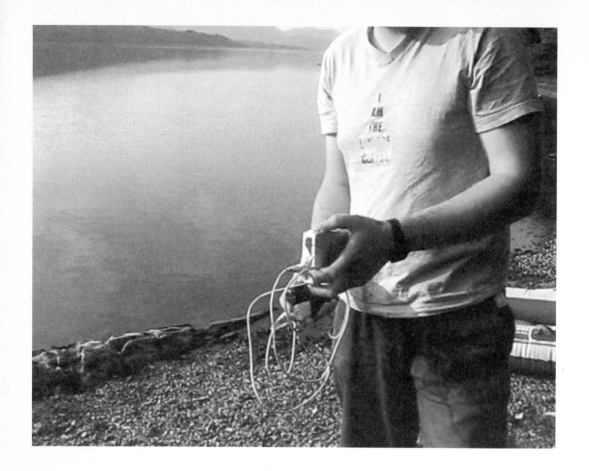

Walkman/Lake

```
2001, video/live work using dinghy, walkman
and cassette
```

Shot on Coniston Water, Cumbria, the site of Donald Campbell's fatal accident during his attempt to break the world water speed record in *Bluebird*. On shore, a cassette of *Metamorphosen* by Richard Strauss was loaded into a walkman, which was taken on board a dinghy, rowed out to the middle of the lake and lowered into the water. For the live version the sound from the walkman was relayed over a pa system on the shore.

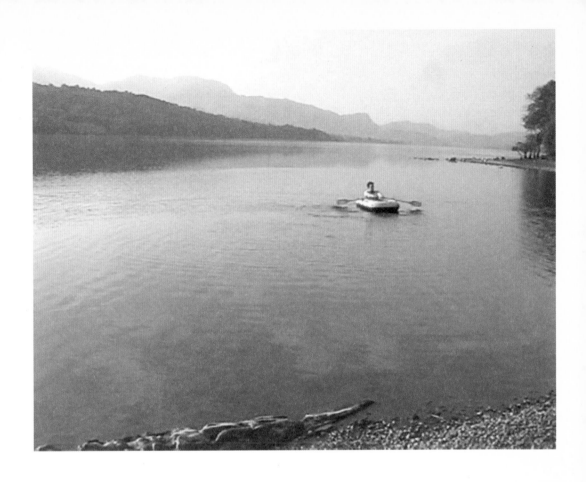

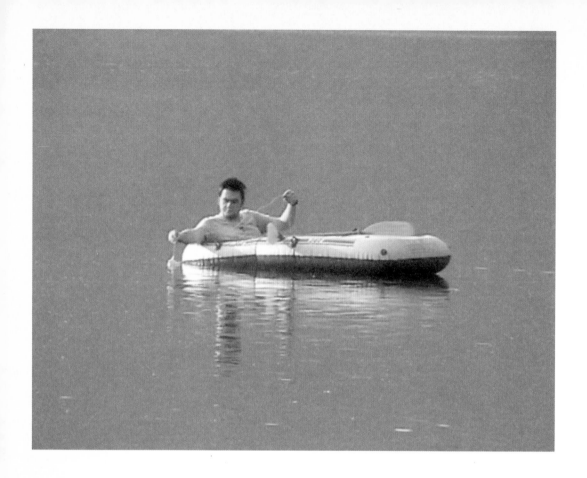

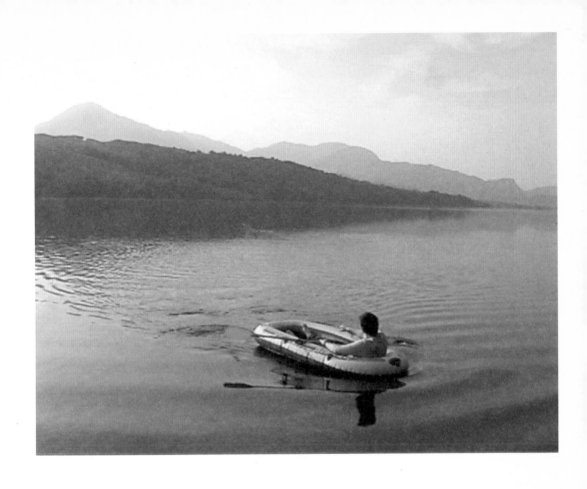

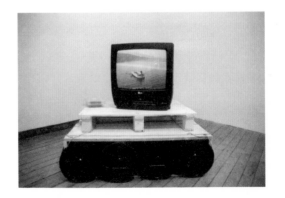

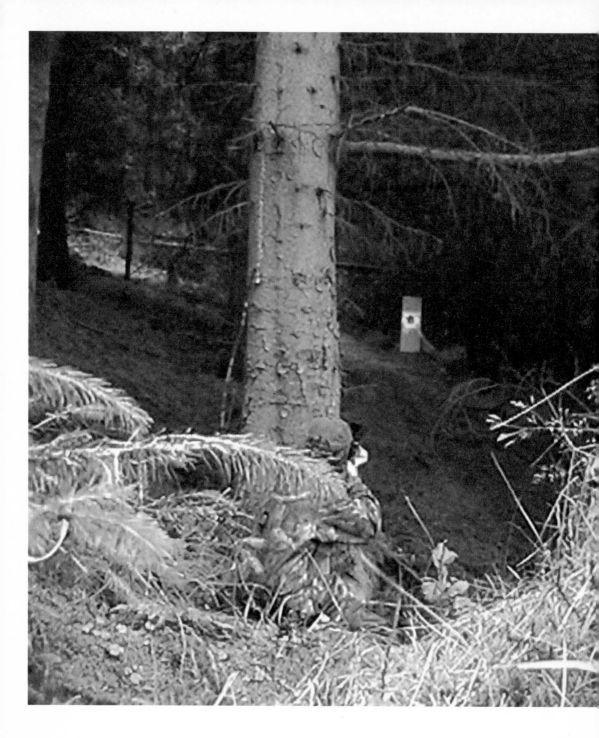

Stalker
`2001, video`

Made in Grizedale, Cumbria, where marksmen employed to control the deer population, known as stalkers, patrol the forest at night. In the film a stalker takes aim and fires at a video camera.

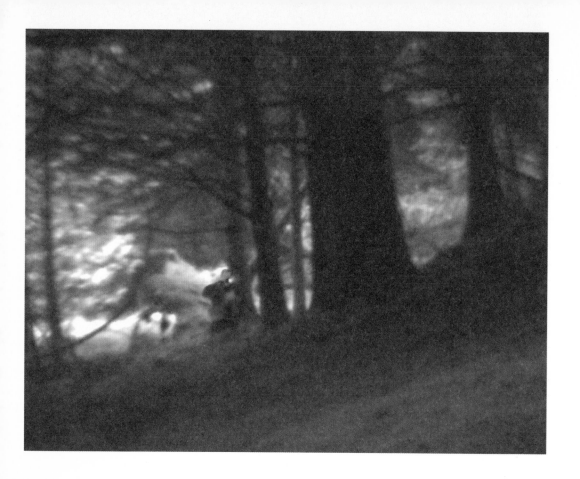

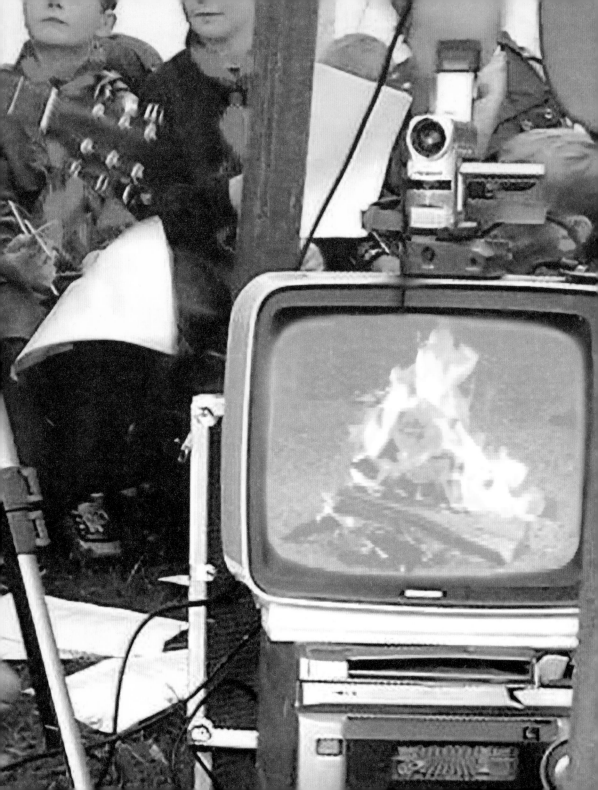

Pastoral ennui

```
2001, live work using acoustic guitars and
digital campfire with cub scout choir
```

A set of urban dance and hip-hop tracks performed on acoustic guitars around a digital campfire. A local Cub Scout group provided the backing singers. Songs included *Better off Alone* by Alice Deejay, *Unfinished Sympathy* by Massive Attack, *Groovejet* by Spiller and *Ready or Not* by the Fugees.

Digital shy
2001, coconut shy-style stall containing
items of information technology

Visitors paid a small sum to throw three wooden
noggins at consumer electronics, replacing the
usual coconuts. Targets included functioning TVs,
walkmans, fax machines and computers.

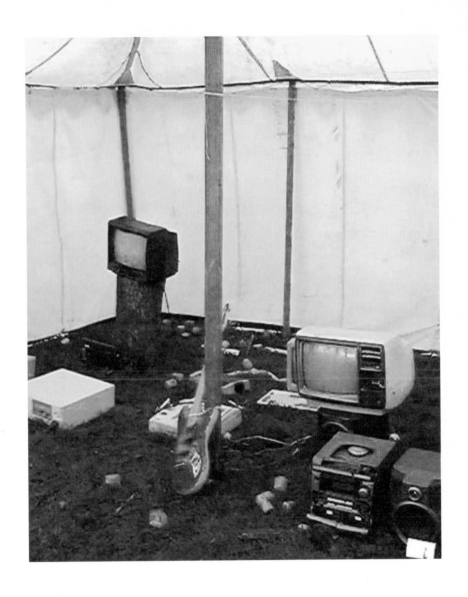

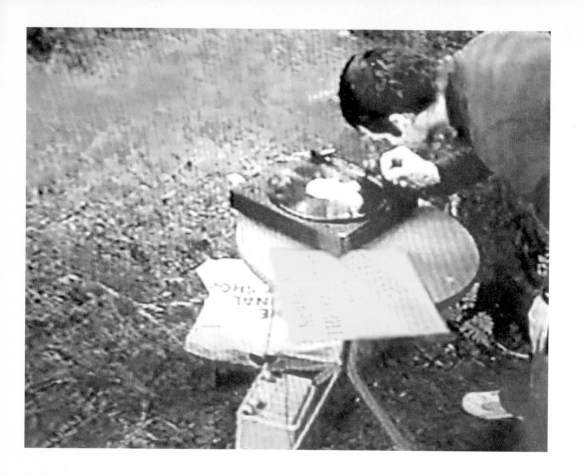

Born in 82
2002, video installation with burnt-out
record player and first edition of the Sex
Pistols' Never Mind The Bollocks LP

Whilst playing *God Save the Queen* a record player,
powered by a car battery, was set alight.

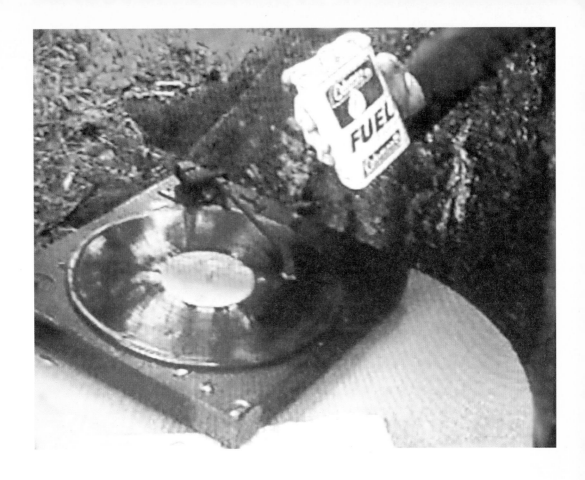

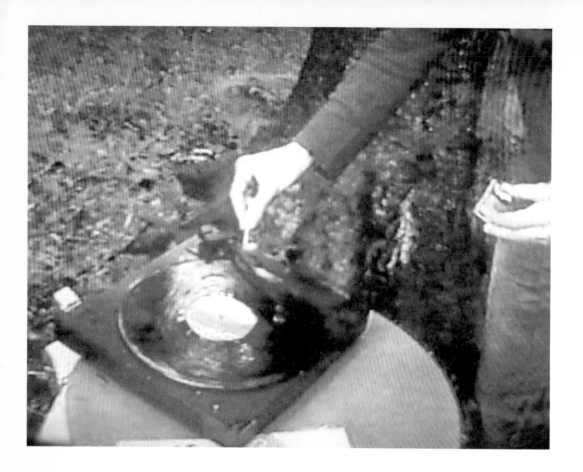

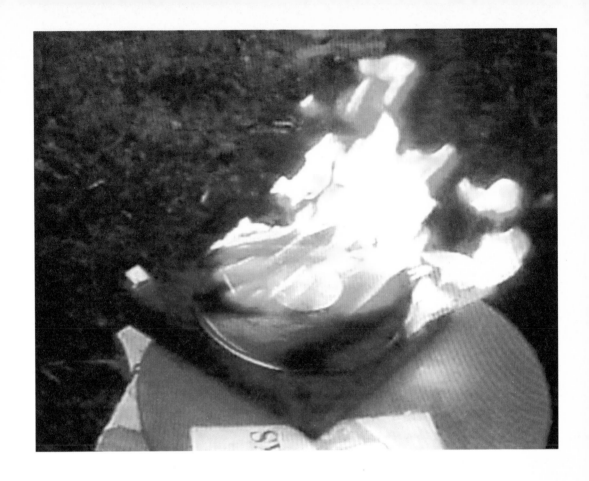

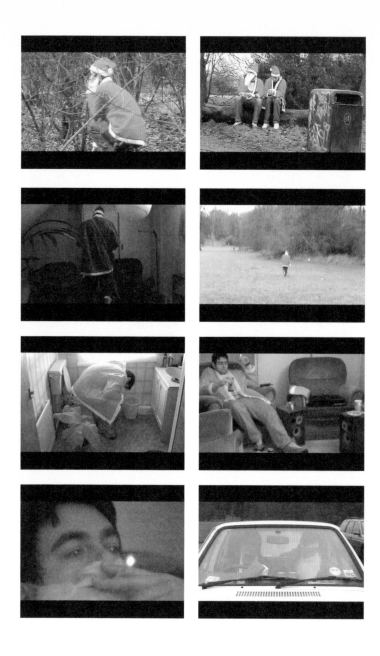

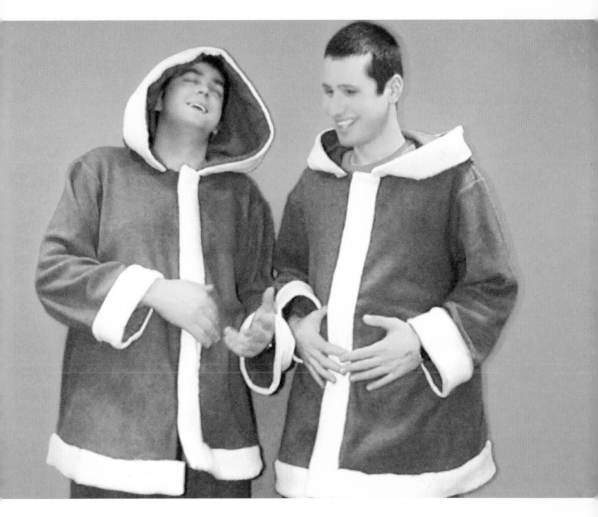

**Like waking from a dream of incest
feeling ruined forever**

`2002, video and performance ephemera`

Originating from a performance at Grizedale Arts'
2001 Christmas pantomime where, dressed as
entirely grey Santas, a series of Christmas songs
were performed in the style of a minimalist electro
band. Footage was interspersed with backstage
shots of the performers wallowing in lonely excesses.

Disc(0)

2002, live work for electric drill, four CD
players and CDs

Each CD contained one part of a specially composed
string quartet piece. The four players were started
at the same time. As the music played, each CD was
in turn removed and a hole drilled through it, then
returned to the player. As this was repeated the
music deteriorated into pops and glitches. Finally
one of the CD players was drilled through while
playing.

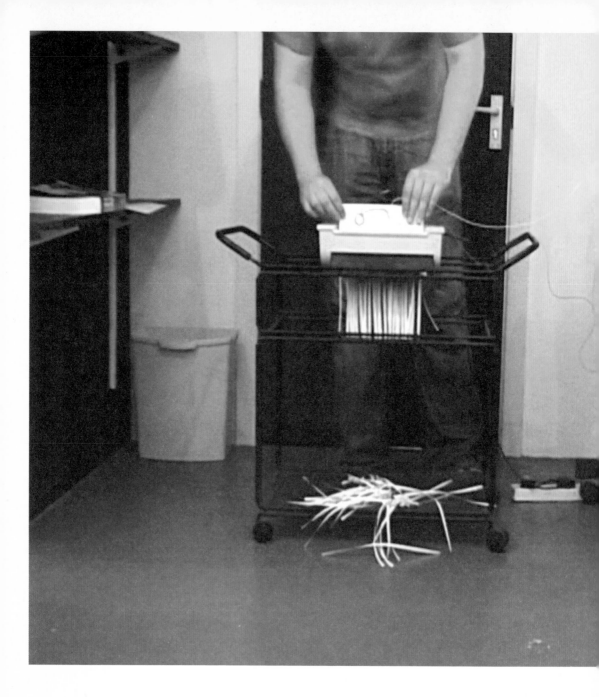

A rich future is still ours

2003, video installation

Sheets of paper, with attached transducer contact microphones, were fed through a paper shredder.

I am swimming through pools of cool water
2003, live performance for mobile phones,
blowtorch and computer software

Keypad sounds and feedback from two mobile
phones were manipulated by computer sequencing
software to create a melodic piece of music which
abruptly ended when one phone was set alight.

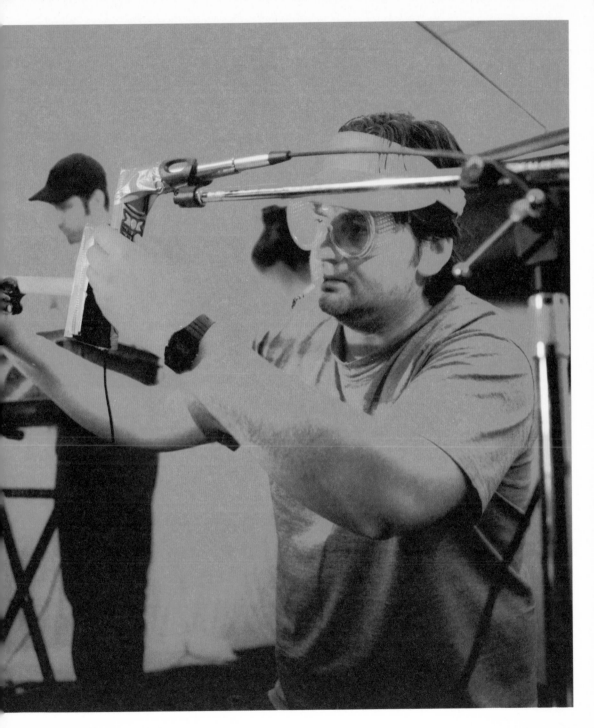

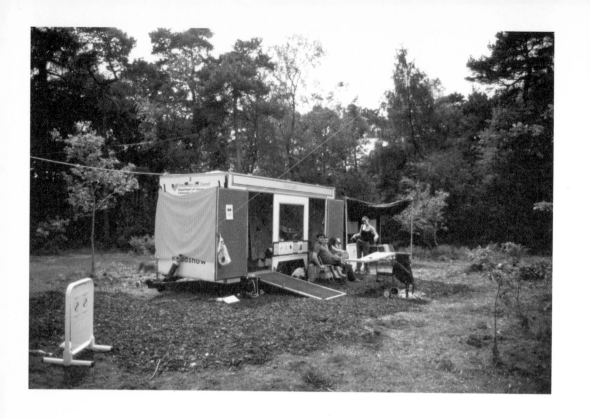

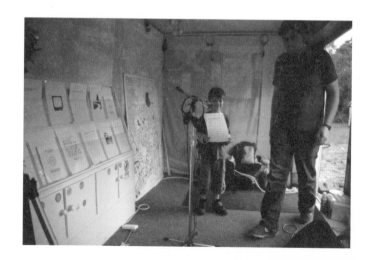

Ban this

2003, live piece, commissioned as part
of Grizedale Arts' 'Roadshow', and video
installation

Visitors to *Roadshow* were invited to write and
record their own song lyrics to a Juneau Projects
backing track. Tracks included the tender soul
ballad *Love like the Stars*, the NYC style hip hop
of *I Still Rule the World*, "...now you boy, you listen
to me...", and the state-of-the-art nu-structualist
metal of *Too Fast, Too Furious*, "...am I going too fast
for yaah...(sic)".

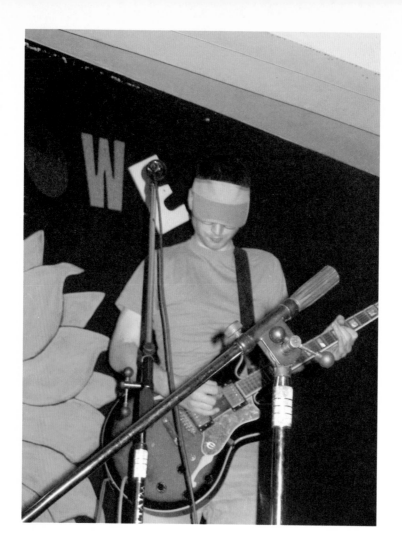

Ban this (the remix)
2003, live performance and audio CD

Recorded songs were remixed and performed live
for *Ban this - the remix*.

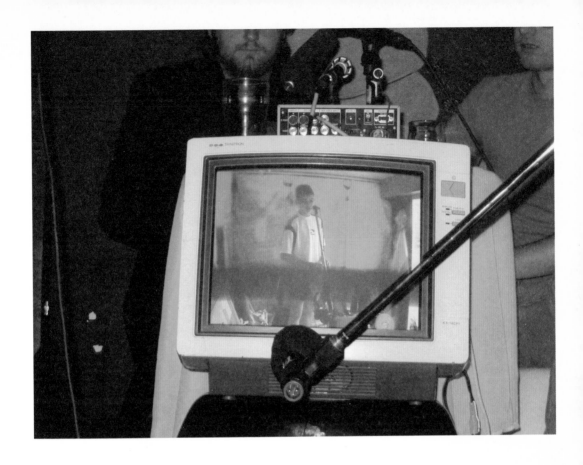

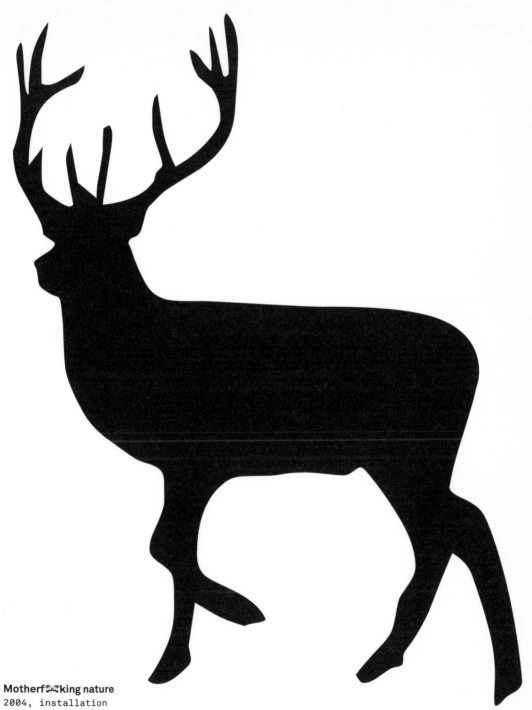

Motherf⬛king nature
2004, installation

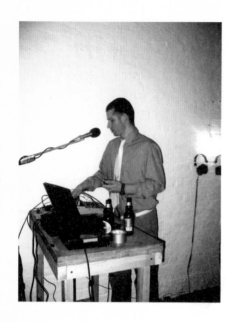

Better off alone workstation

`manned workstation`

Juneau Projects reworking of the Alice Deejay
euro-classic *Better Off Alone* was produced as CDs
with hand-painted covers and hand-etched twelve-
inch records. A live version was performed for the
opening using two mobile phones as instruments.

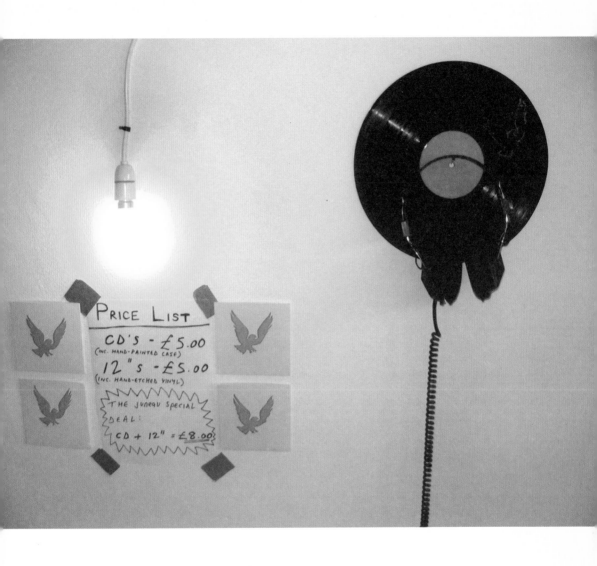

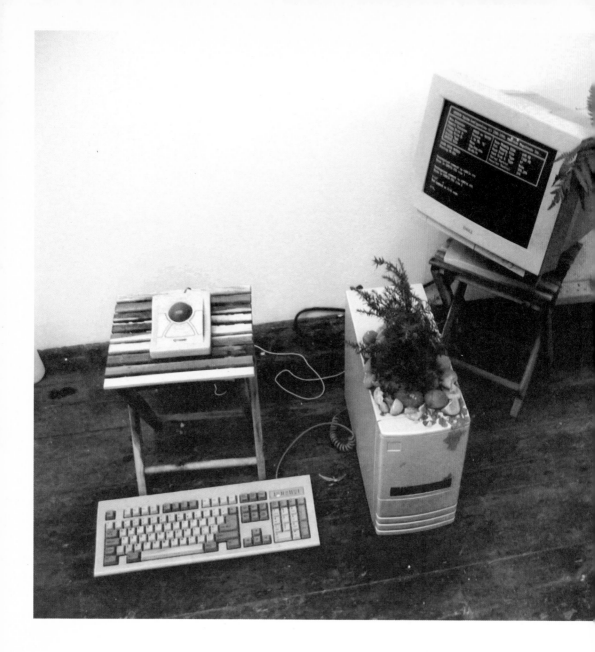

A forest
computer system with a small pine tree
growing in casing

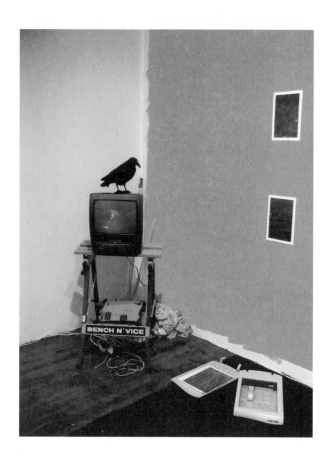

Good morning captain
video installation with inkjet prints

A video of a scanner being dragged across a forest
floor placed alongside the resulting printouts.

My wretched heart is still aglow
video installation

Footage of microphones being lowered into a
campfire relaying their own destruction.

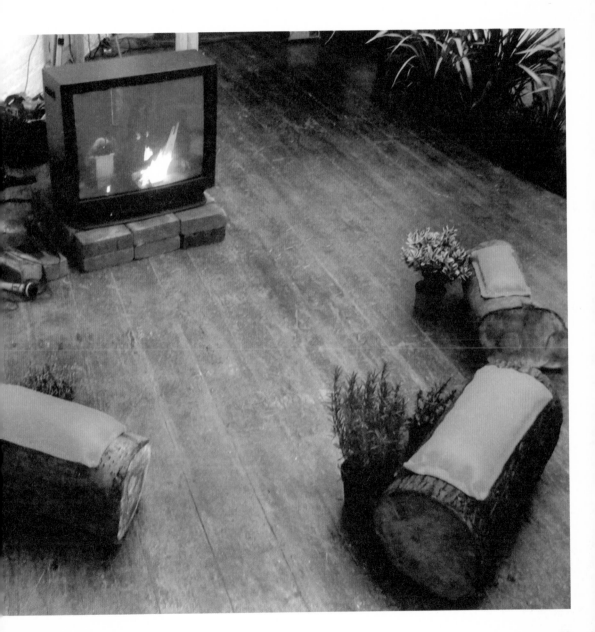

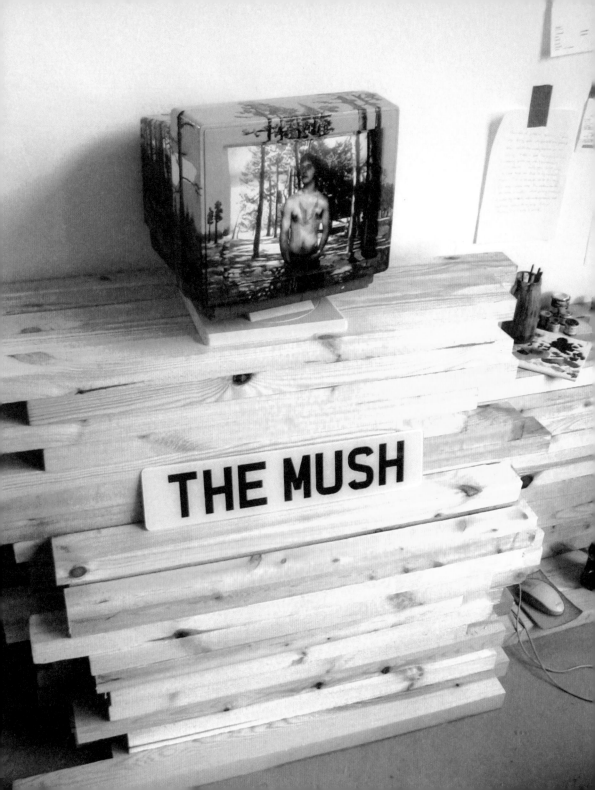

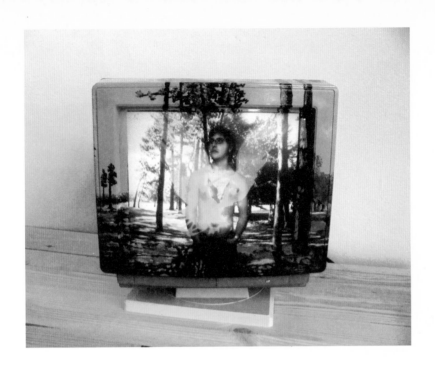

The mush
installation with computer animation on
painted monitor and video

'Placing the stub of his roll up into a pouch at his
waist he rose to his feet laughing and headed into
the woods.'

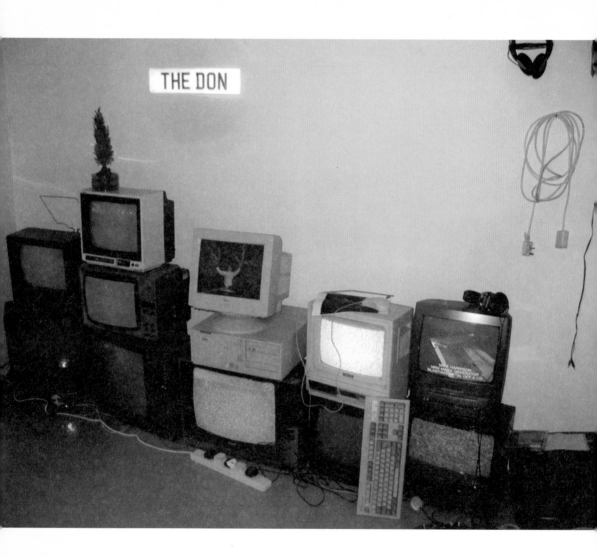

The don

installation with video footage

An installation featuring *the don* shooting lightning from his chain mail covered hands while sitting on a Tesla coil. He is surrounded by televisions with images of wildlife etched into the screens and a monitor of enthusiasts demonstrating similar devices.

The beauty royale
video installation with landscaped TV,
woodchipper and dowel-mounted transducer
microphones

Presented on a TV monitor with hobbyist model
landscape, contact microphones attached to
dowelling transmit their disintegration when fed
into a woodchipper.

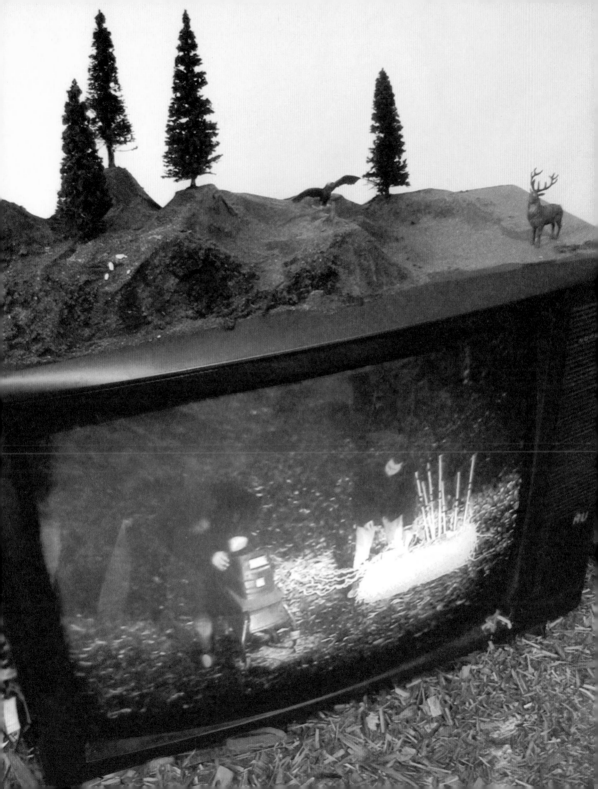

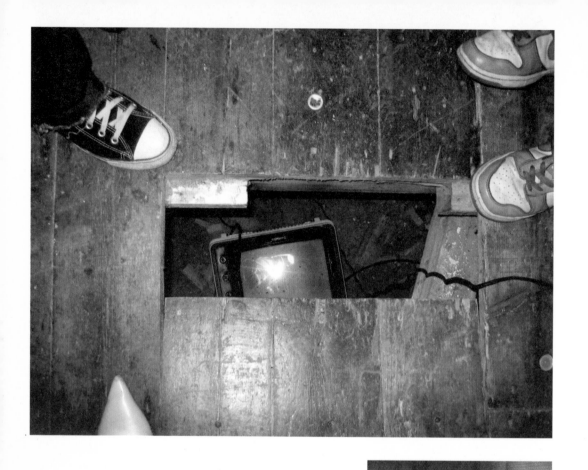

The kingpin
video installation

'I will never forget the intensity of his face...'

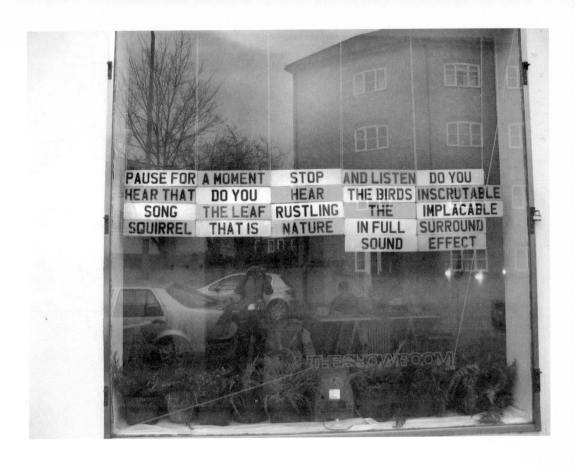

Pause for a moment, stop and listen, do you hear that, do you hear the birds inscrutable song, the leaf rustling, the implacable squirrel – that is nature in full surround sound effect

Car number plates

Driving off the spleen
2004, installation

Adopting the form of a radio play, a narrative was presented on a customised listening post relating to a Lake District episode in the lives of Juneau Projects. Within the installation, sculptural and photographic works embodied the characters of the story.

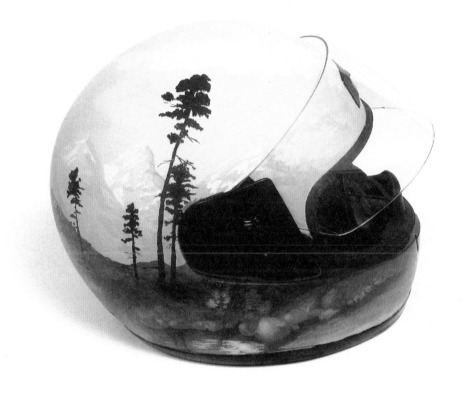

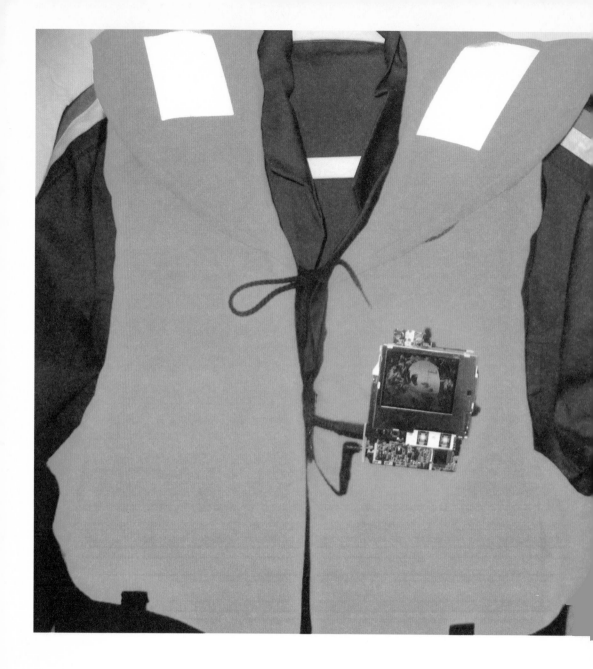

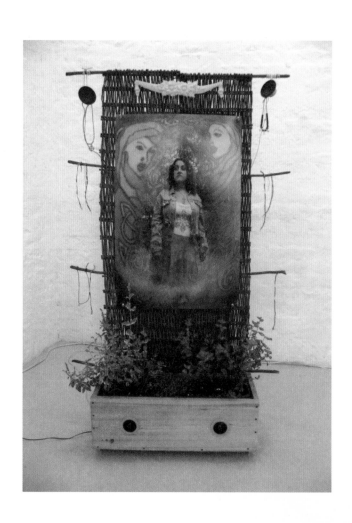

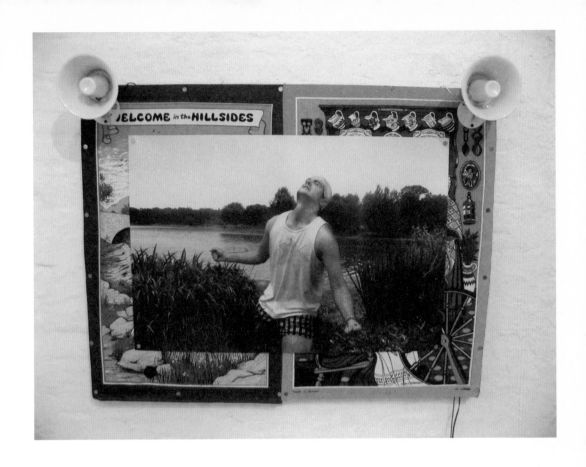

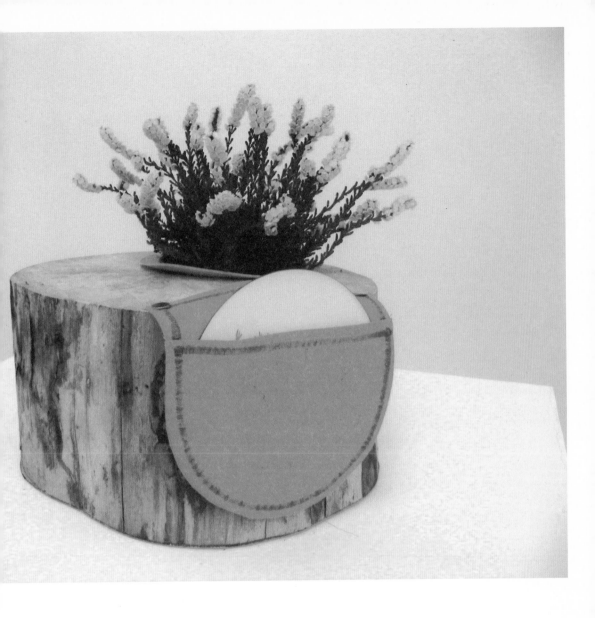

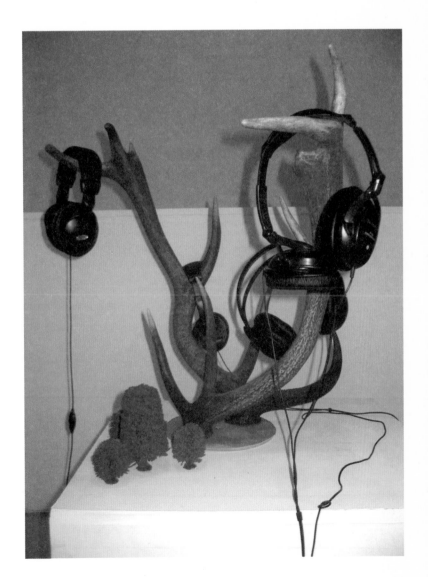

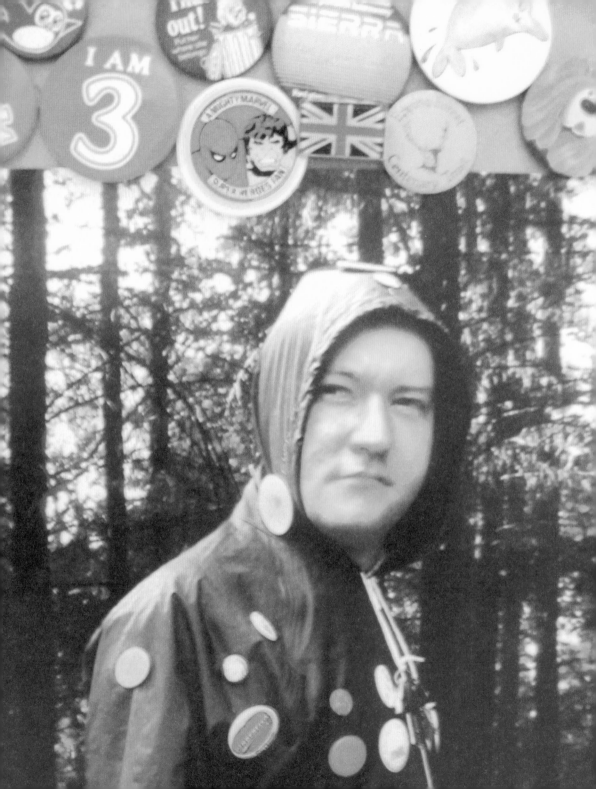

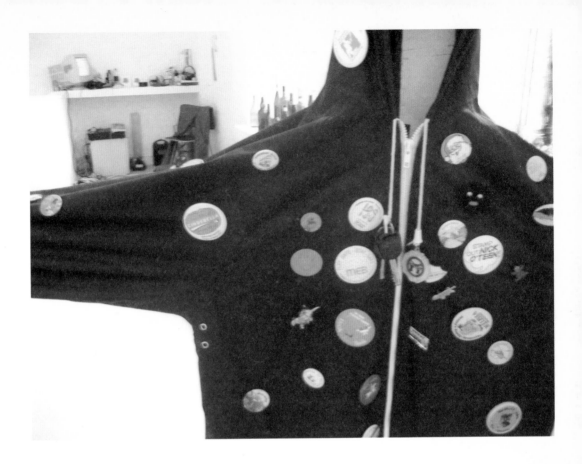

Juneau records
2004, installation and web project

A homespun record label first developed for
Romantic Detachment at PS1, New York. Downloads
at www.juneaurecords.co.uk

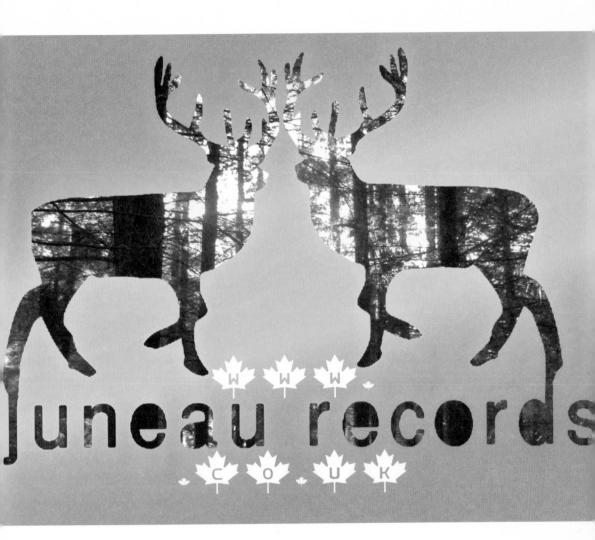

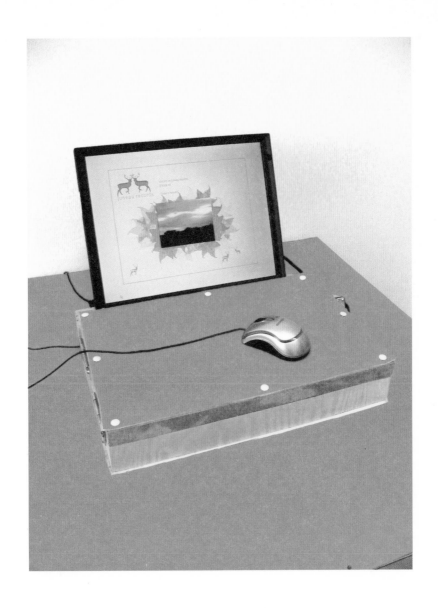

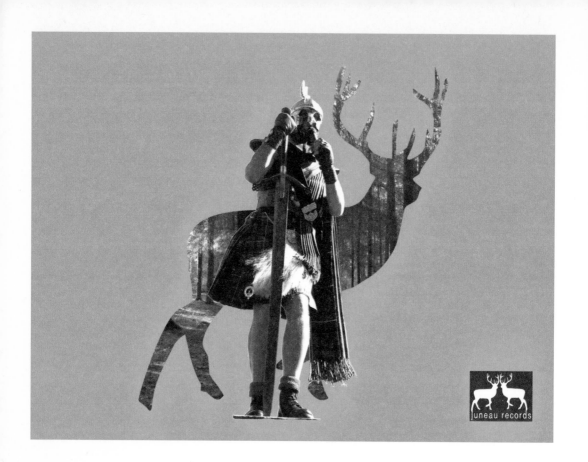

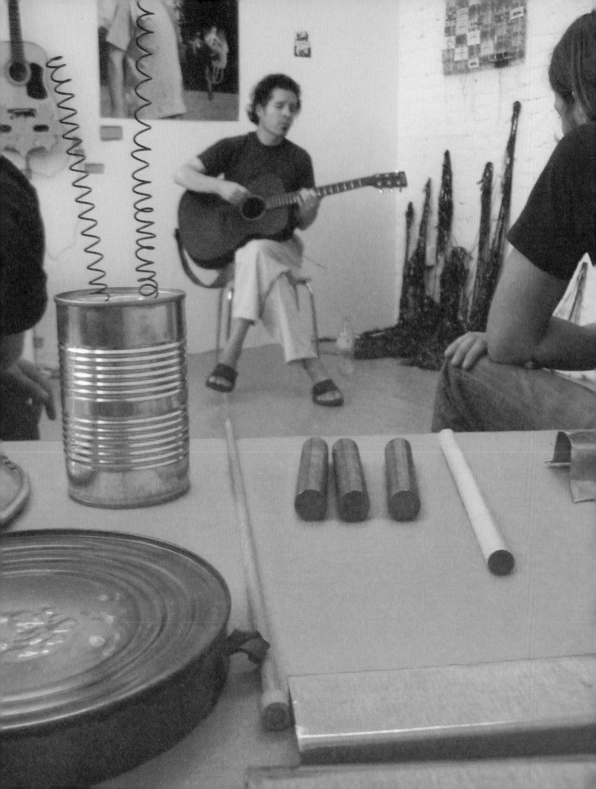

Stag becomes eagle
2005

A music, video and photography project in partnership with the RSBP at Averley Marshes, Essex. Local children and teenagers visited Juneau Projects portable recording studio to write and record their own songs and music. A magazine and audio CD with the highlights of songs and images produced was launched at an event on the marshes where participants performed a selection of their tracks.

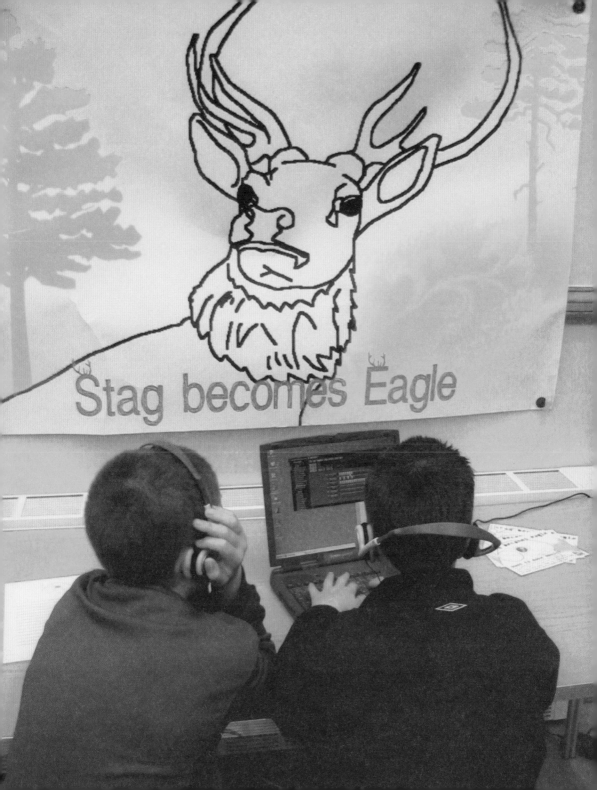

Kyle + Sean

Donkeys go eeoww
Horses go nay,
Sheep go baa,
And cows go moooo,

But, they are all animals,
animals, ani, ani, animals.

Animals

Cats go meow
Dogs go woof
Bird go squawk
But they all are animals

But, they all are animals,
animals, ani, ani, animals,

Donkeys go eeoww,
Horses go nay,
Sheep go baa,
And cows go moooo,

But, they all are animals,
animals, ani, ani, animals.

but

Sean W.

① Boxing Kangaroo
Loves to fight
But watch out
A crocodile might
Bight you
Tonight

② boxing kangaroo loves to
Jump high, fight
right up in the sky.

③ Boxing kangaroo loves eat
grass and leaves but never meat

79

stag becomes eagle
song/ lyrics sheet

Strolling by the river side
watching the tide
see how it comes out and in
when thinking of a wonderful thing.
my brother collects snails
that leave slimey trails.
my sister and my mum come too
and we have lots of things to do
we find some
they live in dark

stag becomes eagle
song/ lyrics sheet

Eagles in the sky
They fly to the mountain
They fly to the mountains
They catch rabbits and birds
With their big long beaks
Eagles in the sky

Lions

Lions roar like a bomb
Lions roar like a bomb
Lions live in Africa, In Africa
Lions live in Africa in the
If I was in Africa
If I was in Africa
They might eat me
They might eat me

11/9/05

stag becomes eagle
song/ lyrics sheet

Track Nº1 or 2

eagles life

© Chour Chip Chrous Jay and Rhys slow

When we're outside
We see all the lovely birds
Birds in the trees
And the lovely smelly flowers
And the bright ones by the bushes

break 5sec

2345! © The lovely shining sun
The children having fun!

break 5sec

© The bees are buzzing and fuzzing
They are scaring children away

© The aeroplane are roaring
as they take people away
The outside isn't boring
Having loads of fun today!

Verse 1:
An eagle is flying above the clouds
looking down at the ground below.
killing everything in its path
taking it back to the family, yeah.
verse 2: the chrous eagles are the best they are
He goes to the mountain nest
to feed the little babies
and the eagle is trying to do his best
to keep them out of danger.
verse 2 verse 3: The chrous
He swoops down to the sea
watching for the fish
For his evening meal,
before he rest his head.
chrous
eagles are the best better

Heart of an owl

2005, CD and live performance

Collaboration with a group of children from Warwick
to produce a set of original songs, based upon
country and western music samples, which were
performed in the grounds of Compton Verney.

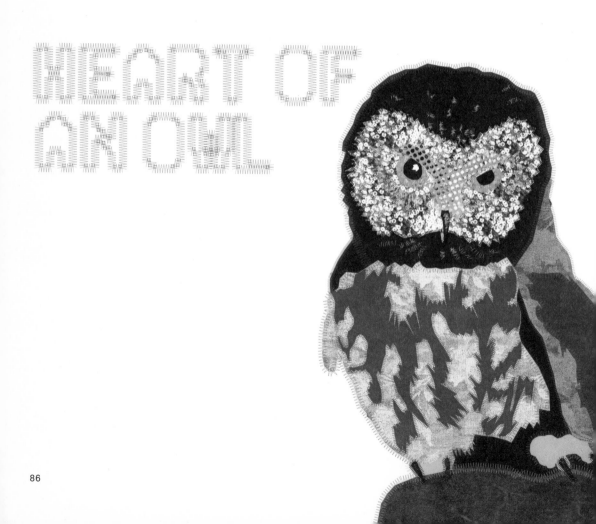

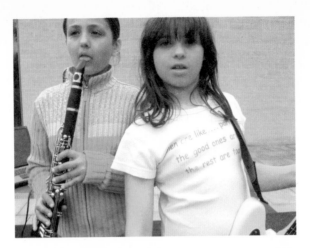

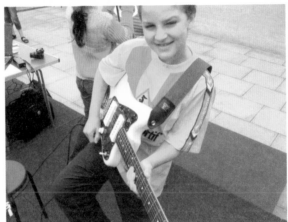

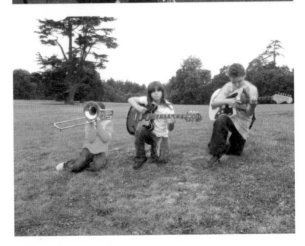

Antler fonts
2005, web projects and installation

Antler fonts featured typefaces designed by
fantasy wargamers. The fonts are available for free
download at www.antlerfonts.co.uk

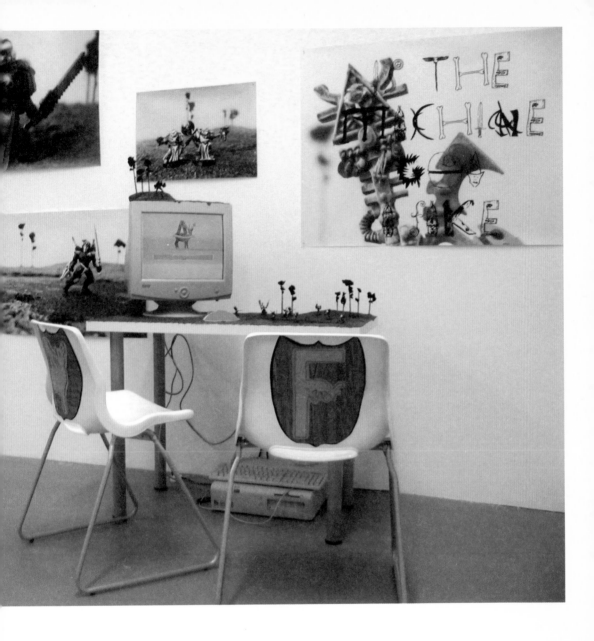

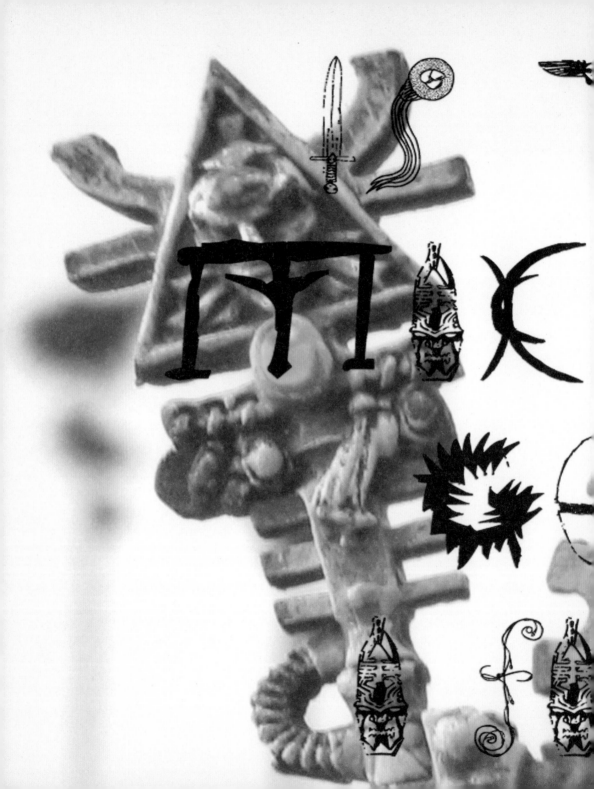

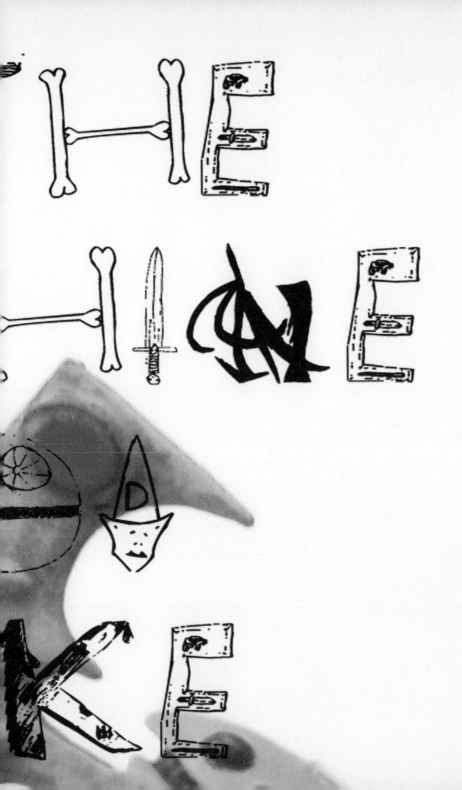

Will I see another highway
2005, installation

A car, with a full tank of petrol, was driven
northwards from Birmingham until it ran out of
fuel. The landscape that faced them was painted by
Juneau Projects onto the broken-down car's bonnet.
The bonnet and other works inspired by sights along
the journey were displayed.

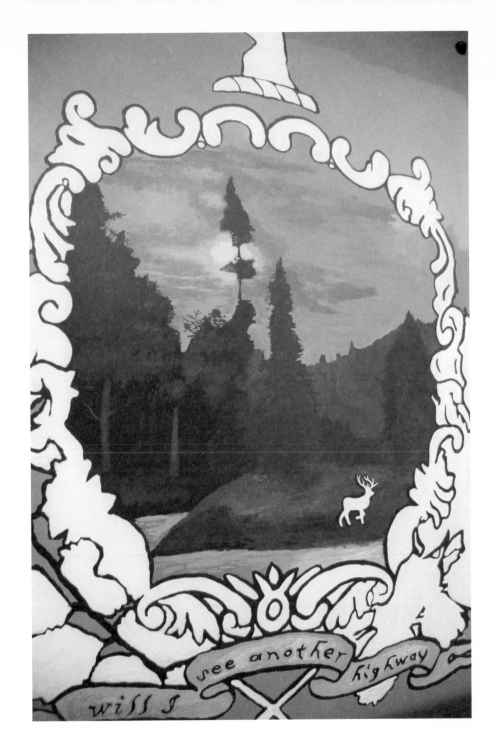

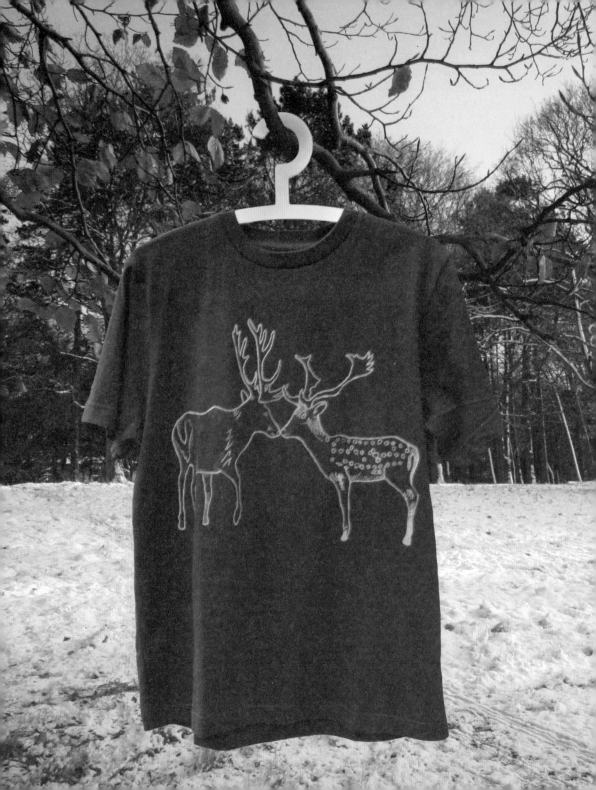

The black moss
2006, installation

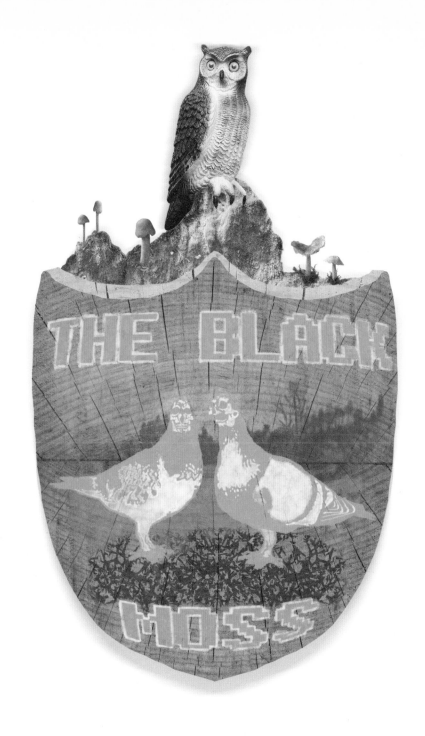

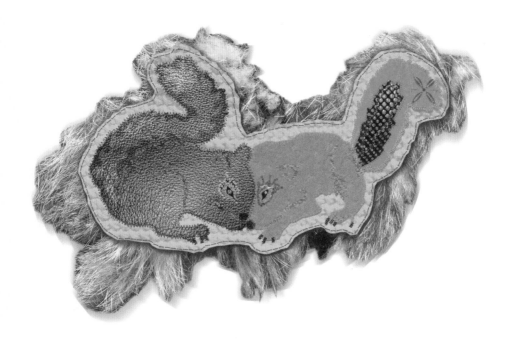

I'm going to antler you

2006, installation

Collaboration with two groups of young people to create the music and costumes of imaginary rival bands *the embers* and *the ebony angels.*

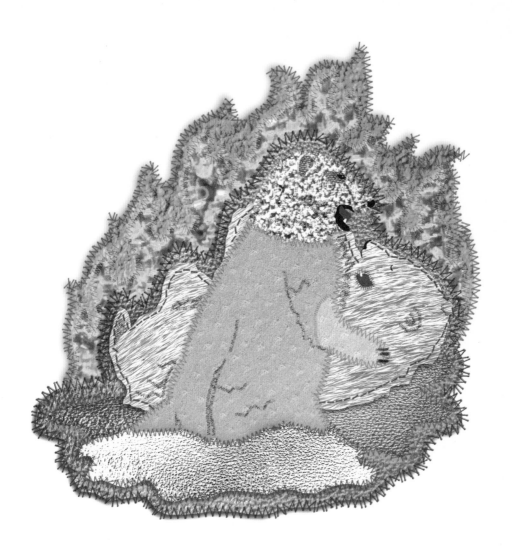

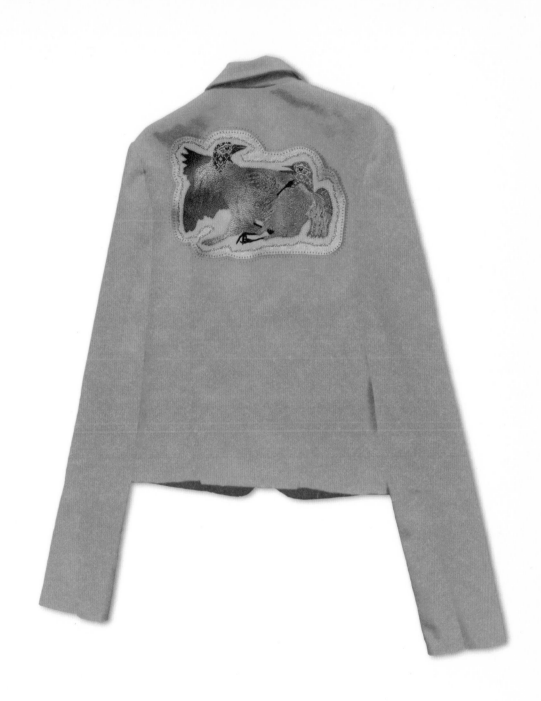

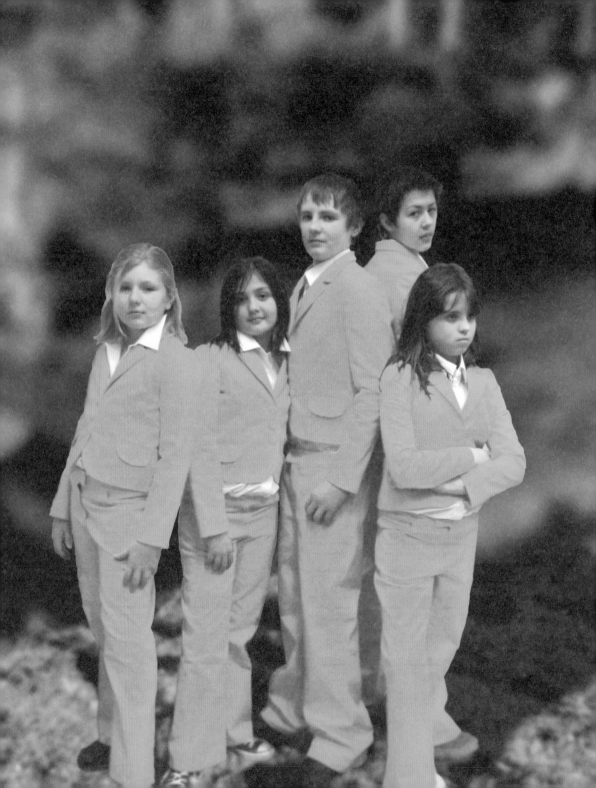

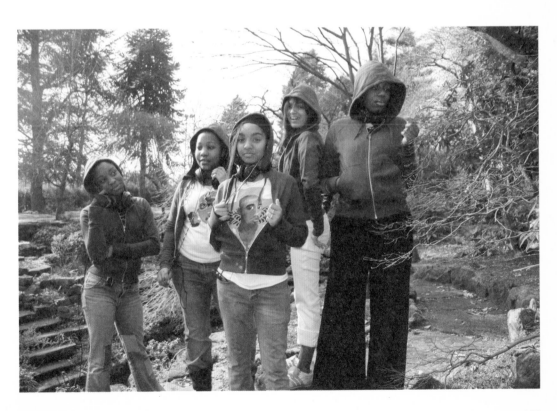

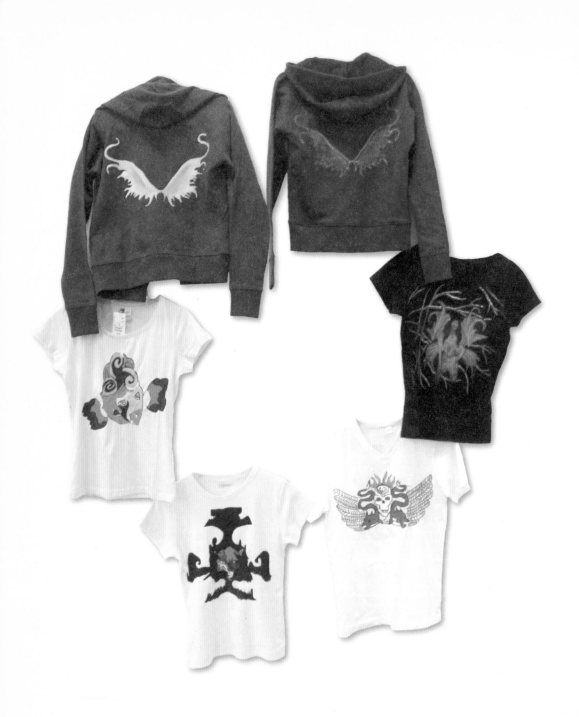

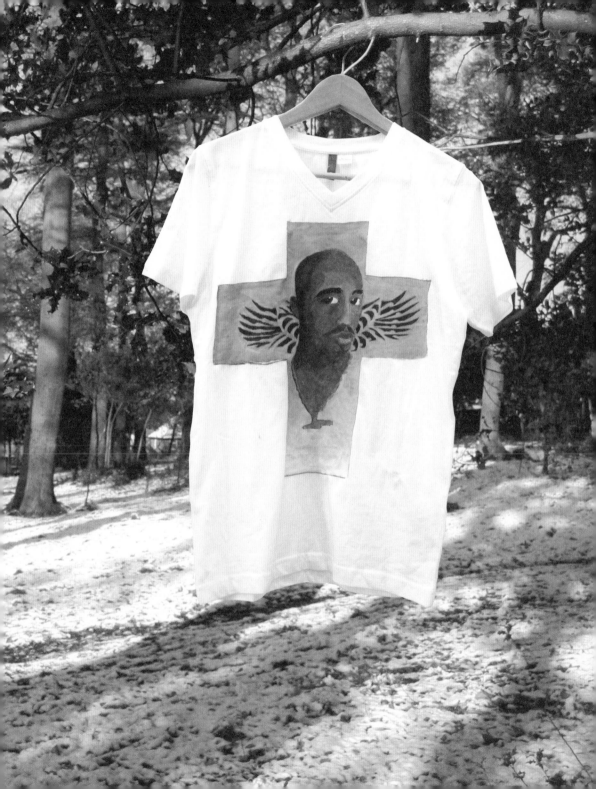

Beneath the floorboards of the forest, empty space
2006, installation

A text-based computer game presented on
customised plinths.

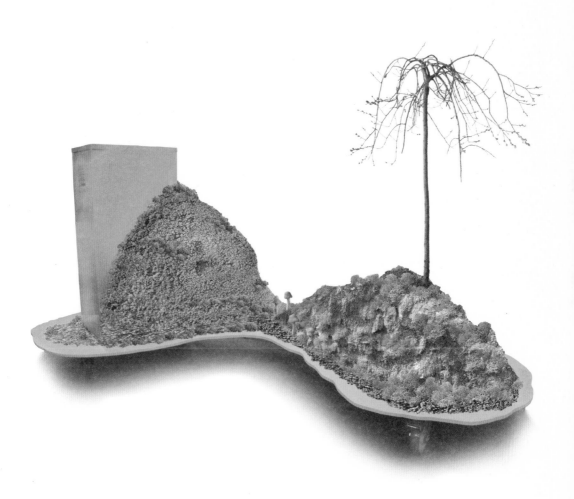

YOU AWAKE IN A FOREST. THE EVENING SUN IS DAPPLING THROUGH THE BRANCHES OF THE BONE-WHITE SILVER BIRCHES THAT SURROUND YOU. THEY HAVE SMALL PURPLE HEART-SHAPED LEAVES, WHICH ARE SO DARK THEY APPEAR ALMOST BLACK IN THE EVENING LIGHT. YOU ARE LYING ON YOUR BACK ON THE MOSSY FLOOR. SMALL COLOURFUL FUNGI PROTRUDE FROM THE MOSS AND FALLEN LEAVES. YOU LOOK UP INTO THE BRANCHES AND GLIMPSE A RUSSET COLOURED WOOD PIGEON WITH WHITE MARKINGS. THE MARKINGS SEEM TO BE GATHERED AROUND ITS HEAD AND FACE IN A PECULIAR WAY; THE BROWN PLUMAGE IS PREDOMINANT AROUND EYES AND BEAK WITH LARGE AREAS OF WHITE ON THE HEAD AND CHEEKS. IT LOOKS AS THOUGH THE MARKINGS ARE DESCRIBING A HUMAN SKULL ON THE BIRDS HEAD; BUT BEFORE YOU CAN BE SURE THE PIGEON FLIES OFF. YOU ARE LEFT ALONE IN THE GLADE PONDERING WHAT SEEMS TO BE A STRANGE AND GRIM PORTENT. SLOWLY YOU GET TO YOUR FEET AND PICK UP YOUR BAG.

YOU STAND MOMENTARILY CONSIDERING WHICH DIRECTION YOU SHOULD TAKE. SOMEWHERE IN THE DISTANCE YOU HEAR A

INTO THE BRANCHES AND GLIMPSE A RUSSET COLOURED WOOD PIGEON WITH WHITE MARKINGS. THE MARKINGS SEEM TO BE GATHERED AROUND ITS HEAD AND FACE IN A PECULIAR WAY; THE BROWN PLUMAGE IS PREDOMINANT AROUND EYES AND BEAK WITH LARGE AREAS OF WHITE ON THE HEAD AND CHEEKS. IT LOOKS AS THOUGH THE MARKINGS ARE DESCRIBING A HUMAN SKULL ON THE BIRDS HEAD, BUT BEFORE YOU CAN BE SURE THE PIGEON FLIES OFF. YOU ARE LEFT ALONE IN THE GLADE PONDERING WHAT SEEMS TO BE A STRANGE AND GRIM PORTENT. SLOWLY YOU GET TO YOUR FEET AND PICK UP YOUR BAG.

YOU STAND MOMENTARILY CONSIDERING WHICH DIRECTION YOU SHOULD TAKE. SOMEWHERE IN THE DISTANCE YOU HEAR A STRANGE AND FOREBODING SOUND. IT IS A KIND OF PINGING NOISE WHICH SEEMS AT ONCE NATURAL AND UNEARTHLY — THE SOUND OF AN IMPLACABLE FORCE PROBING AND PRODDING AT THE WORLD FOR AN INSCRUTABLE INTENTION.

WHICH DIRECTION WILL YOU GO NOW?

N

Thoroughly modern miracles

Adam Sutherland and Ceri Hand exchange memories of Grizedale and Juneau Projects

AS I thought Juneau was a mythological reference that they had spelt wrong – it's actually drawn from the title of a book and spelt wrong. My first encounter was when they were taking part in a residential performance get together in Cumbria, an event led by a local artist with some long evaporated pedigree as a performance artist. For some reason I was being 'kept in the loop', which meant constant updates on who was coming. They were billed as the hip young component alongside storytellers, tree lovers, witches, shamans and dumb conceptualists.

This event was as good an experience as two shambling boys edging out of the art school doors could expect to have, a week with one of the most eclectic and downright hellish groups of people ever assembled in a long thin dormitory. Their subsequent five-day experience in this forest shack seems to have informed all of their work to date, being constantly revisited as they try to 'work through' the trauma. It's that horrific residency model that's been so influential, driving young artists forward to seek alternatives. Although it must be said there is a certain taint of desperation forever staining all the work born of this kind of experience and certainly the same must be said of the Juneau's work, you always sense the wet breath of the hell hound in there somewhere. I did meet them on this occasion, two, difficult to get into focus, fuzzy boys staring at their own feet mumbling with a girlfriend called Jenny. One cannot deny the impact of the girlfriend in their work, never mentioned but ever present. It's rock and roll, but it's the kid brother version.

Over the years that Juneaus have made work at Grizedale I was slowly able to piece together what had really happened in the shack, through brief moments of shattered

recollection, stumbling references and embarrassed silences. Any audience of their work will also be familiar with the cast of characters, 'Small Hands Paul', the poet, Taffy Thomas, the (is he Welsh? No) story teller, the old school performance artist, the landscape shaman. Taffy kept the assembled group up deep into the early hours with his interminable stories of Westcott's. The boys eventually tried to stop him, hurt him – humiliation, sarcasm, insults, and realised in those moments what it was to be in the art world, the full deep wet red version, not the homely confines of the self-supporting art school/London scene. From that moment on Juneau Projects haplessly tried to reinvent what it might be to be an artist; they haplessly continue.

I traditionally always used to introduce them, incredibly badly. I remember once doing it in a terrible American accent for no apparent reason, introducing them once when the entire audience was in another room (as were the Juneaus). For their part they endlessly tried to render popular songs into quasi-listenable form, both of us aware of each others shortcomings – but assuming it's done on purpose and means something – while being unaware of our own. They still look shocked when I suggest their singing is out of tune.

The last time I wrote a text for Juneaus it got butchered by the gallery. They kept arguing about whether people would understand what cupping was or was there was such a word as defucked. What with the edit/rewrite and the art catalogue graphic design I was finally ashamed of the way my text looked and read, THEY PUT TOO MUCH LIPSTICK ON MY GORILLA (and a little eye shadow).

CH My first encounter with Juneaus was through performances past, when I was about to start at Grizedale and was studiously trying to get up to speed with all the freaks and weirdos that had gone before. I came across images and descriptions of 'Digital shy' – where they were lobbing coconuts at a load of defunct electrical equipment and trying to charge the public to have a go – and 'Like waking from a dream of incest feeling ruined forever' where, with faces lifted straight from Raymond Biggs, they were dressed as grey Santas.

Eventually they appeared out of the dewy mist early on the 'launch' morning of 'Lawless' (the Grizedale car boot sale of 2002) where they arrived in the meadow in what looked like their Mum's car, with a load of 'art' they'd hoisted from their own collections and re-packaged with hilarious hand made labels. They settled in amongst the tat, tinny carousels, balloon 'artist', cartoonist and shite local ceramics like they'd been born to booty.

It was their performance that evening that hooked me, transforming themselves from two timid teenagers with their own language system, by delivering heart-wrenching performances of Miss Dynamite's 'It Takes More' and Eminem's 'Lose Yourself.' They conveyed an exhilarating, exciting, hilarious, melancholy and thought-provoking set that convinced me on the spot that if ever I were to get married I'd invite them to perform at the 'do'. Those boys know a thing or two about romance, which reminds me of dinner one night in the communal dining hall of Summerhill when Phil told this amazing tale of discovering a butterfly somewhere odd in that nice peaceful manner he has. He glazed up in the ole eye sockets, making me think it was the most earnest and beautiful tale a lad has ever had the sincerity to tell.

I think that's the Juneau's USP – sincerity. They really do mean it.

AS Those Juneau stories of innocence are great. When aged seven in Birmingham, Ben had seen, in passing from the car, a martial arts shop, and persuaded his parents over the course of a year to let him go there for his birthday treat. The great day finally arrived only to find that it was actually a marital aids shop, complete with leather and whips window display, as he stood outside flanked by his parents.

There is a lot of honesty and pathos in their work, romanticism, disappointment. That thing they did ('Walkman/ Lake', 2001) when they got a gallery director to suggest a sublime piece of music ('Metamorphosen' by Strauss), established the ultimate backdrop for playing it (Coniston Water) then set about destroying it visually with the addition of a rubber dinghy and aurally by lowering the cassette

player into the lake while broadcasting its conversion into a series of bleeps and squeaks. Construct and deconstruct, a piss take, Bart Simpson's sound of one hand clapping, easy tak tak. Or in a different way the wall text about the wood chipper, a poignant thumbnail sketch about contemporary relationships, so sad and mean all at once:

The old couple didn't need it anymore. There was nothing left to chip, just woodchips and earth. The once great fir trees in their garden were now a mound of shavings next to the shell of a red brick barbecue. They offered us tea. We said we couldn't stay. They asked us if we did a lot of gardening. I said "we're from London…" They looked away. I handed them the cash. In five pound notes as they had requested. And we left. As we loaded it into the car we noticed written in permanent marker on the side of the chipper, the words 'To Mom & Dad with love.' We drove off in silence.

I think what Ben and Phil have been trying – maybe not entirely consciously – is to find a bearable way to make art, dealing with stuff they are actually interested in (and slightly embarrassed by) rather than the stuff the art world still loves. Of course every generation does this, in turn quickly becoming absorbed back into the mainstream and into traditional material. It's impossible to engage with either of them on the subject of what they are actually trying to do, as this conversation would be exactly what they were trying not to do. It's a sort of revolution but we can't use that word, it's too 'big romantic statement'. They are getting on themselves now and there will be a younger generation around now being bored and disgusted by the Juneau's 'community work' and old sound art.

I think the use of a single name, juneau/projects/ (no capitals, like a subheading, denying the individual, the genius), their areas of interest, the respect for popular culture, children's voices, nice old people, the use of the idiot savant/naïve/folk culture, are all part of dealing with material distinct from the usual histrionics of 'art subjects'. Their territory is suburban pathos, the second bests, the enthusiasts. It's ironic that they should now be embraced by, and are nervously embracing, more mainstream venues. The rejection of which I had always assumed was the basis of their 'vision'.

CH It's interesting that they are frank about their earnest attempts at being performing artistes:

"The music performances we've done have come out of an illicit desire to be on stage, basking in the glory of a hot stage light, fuzzy with Stones bitter. We like to think that, under all the boys-in-their-bedroom bravado beats the heart of a soul man. We often didn't realise until afterwards that what we were doing was funny".

The tragic-comic touch is what they have in spades and in a way is sort of old-skool like the best moments of Charlie Chaplin, Peter Sellers or Tony Hancock. When they get it right, we are drawn into their world and are reminded of some of the finer things in life and of how stupid we were for forgetting them in the first place. Eminem's lyrics from my favourite performance by the Juneau Projects ('Lose Yourself'), cornily sums this up for me – a desire to just go for it and do it, no matter what that is.

I'll never forget seeing them trying to lock themselves into their Mobile Command Unit (cunningly doubling up as a caravan), parked in the middle of a football pitch in Blaneau Ffestiniog on the last leg of Grizedale's 'Roadshow' tour. The kids were so 'into' the project they were prepared to almost kill the Juneaus to get their hands on the kit destined to make them local legends. I don't think I've ever seen two artists look so frightened by their own success; the caravan rocking violently with Phil and Ben rattling around inside like two peas in a jam jar, waiting for them to get bored and go back to hassling the Hermit. Having said that I do think they were amongst the very few artists on the tour willing to really embrace 'socially engaged' in all it's Jekyll and Hyde guises, as we'd hoped.

They're working with kids more and more now in terms of writing songs and performing and recording with them. They seem to enjoy the surprise element of what children come up with and their non-art world attitude. Again that gloriously naïve head rears itself, as the rest of the world might think this is dodgy and weird, but Phil and Ben think it balances out the 'seek and destroy' side of their practice in a cosmic, karmic way. Either way it's tough not to be moved by some of the lyrics and performances they eke out of the mouths of babes.

It's interesting what you say about their name choice – it does seem as though they are 'branding' themselves more and more now when they do shows. They're making these really strong graphic identities which appear on all gallery/ project press and print, T-shirts, ties, CD covers etc. Maybe this is their last cry to have some authorship and control before they're sucked into the Gallery abyss?

AS I think it's more likely to be their first cry of authorship. It seems to me the gallery system requires the idea of the individual, the heroic genius, as transformer; it's part of the marketing of the idea of the artist. I understand the artist's urge to be in there, it validates their work formally, sets a benchmark, identifies the individual but I am also disappointed that the alternatives to the gallery system still have so little status; they are valued, but differently. It's not that I think it matters really, they have – it would be argued – different functions, but when it all comes down to it the real support goes with the status. The big bits of real estate that culture invests in are in the end what suck up the cash and in many ways that cash supports the idea of the institution, not the artist. It is all tied inexorably into the idea of art and what art is for, i.e. status enhancement rather than usefulness, consolidation rather than creativity and so on.

Over the years Juneau Projects have had a big influence on Grizedale and how it has developed, their balance of cynicism and romanticism, making work that brought a contemporary sensibility into relevant play with the romantic and idealist possibilities of the rural. They were really among the first of the Grizedale artists that used people's skills in their work collaboratively. Other artists 'use' other people's creative work, ultimately transforming it to be their own, other artists foreground creative activity as the output, but Juneaus seem to retain a balance. You don't feel the result belongs to them and you know it doesn't entirely belong to the creator – delicately amplifying the pathos of the human condition through the mouths of others. It's that refined sense of balance that makes them special.

It's funny that neither of us has focused on the 'other' work, the destruction of electronic items, quasi-religious themes

of 'modern miracles and martyrdoms'. They don't seem to fit in with our thoughts, but in a way this work is filled with the same sincerity and romanticism, the search for meaning, a hidden message. I've always found the technology/nature equation a bit too simplistic, but when they find the right lyrical balance, such as with 'Walkman/Lake', these works have a resonance that's very much part of Juneau world, life changing moments for quieter people. I recall now when I first met them I told them a story (with reference to their technology destruction ideas) from my teenage years in 70s Devon, sitting on the beach, stoned, with the radio on. This older hippie guy suddenly starts building a fire round the radio, and as the fire blazed the radio picked up the Beach Boys', 'Good Vibrations', playing out through the flames the song gradually distorting, other channels interfering as the mechanics died – we all just sat there staring. Juneau Projects did a version, 'Mic Campfire' in 2001. Lowering microphones into a fire, while they sat around in beach visors on deck chairs, one of the burning microphones in its final moments of agonised groaning somehow picked up a signal and a tiny voice came out of the fire saying 'YOU GOTTA PARTY AND HAVE A GOOD TIME CAUSE YOU IS A LONG TIME IN THE GRAVE'.

CH I always preferred watching them live than seeing video documentation. I think these works are the pathway to something more interesting – you need to know that work to understand where they are now. They'll probably continue to do live performances, but I wonder how long the smashing things up will last?

I know it's incredibly fashionable but I do like the craft work they've done (a traditional journalist would point out the feminine quality of this medium here I think) with all that embroidering animals, and painting and drawing, but with some macho helmets ('The Man of Speed's Helmet', 2004), and bikes and biker jackets thrown in. It's straight out of the Ambleside flower show, so sweet. It's important for us to continue to work with artists that interest and excite us, and continue to offer the public something that you can't find in any other walk of life. I really want us to reflect the multi-layered approach they have to making art. We all need some Juneau dust and so it's nice to show a fucked up but beautiful take on things.

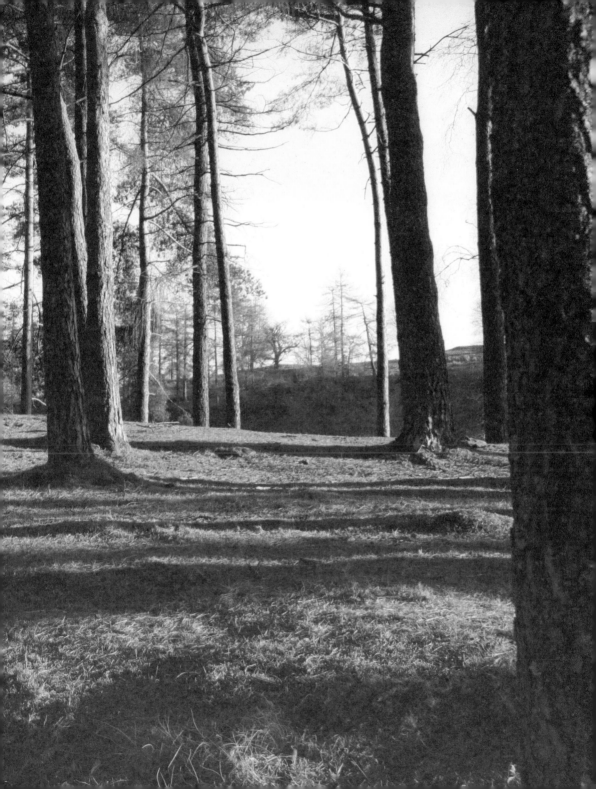

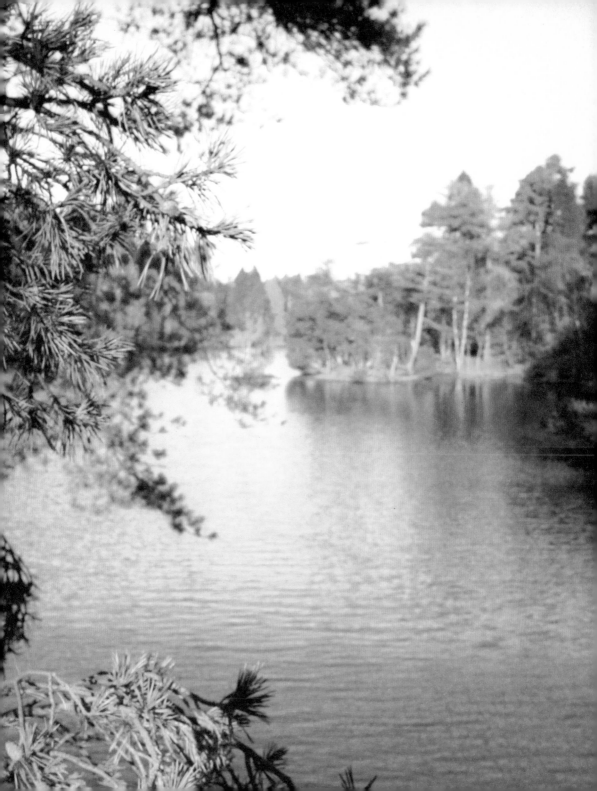

Juneau Projects
The black moss

Ikon Gallery, Birmingham
29 March – 14 May 2006

Wysing Arts Centre, Bourn
29 May – 30 June 2006

Model Arts and Niland Gallery, Sligo
18 September – 8 November 2006

FACT, Liverpool
8 December 2006 – 21 January 2007

Glynn Vivian Art Gallery
28 April – 22 July 2007

Exhibition curated by Nigel Prince

Ikon Gallery
1 Oozells Square
Brindleyplace
Birmingham B1 2HS
t: +44 (0) 121 248 0708
f: +44 (0) 121 248 0709
www.ikon-gallery.co.uk

Glynn Vivian Art Gallery
Alexandra Road
Swansea SA1 5DZ
t: +44 (0) 1792 516 900
f: +44 (0) 1792 516 903
www.glynnviviangallery.org

Ikon gratefully acknowledges financial
assistance from Arts Council England, West
Midlands and Birmingham City Council.
Registered charity no.528892

Glynn Vivian Gallery acknowledges financial
assistance from City and County of Swansea.
Supported by a grant from The Arts Council
of Wales

This exhibition is supported by the Arts
Council England National Touring Programme
and the Henry Moore Foundation

Distributed by Cornerhouse Publications
70 Oxford Street
Manchester M1 5NH
t: +44 (0) 161 200 1503
f: +44 (0) 161 200 1504
publications@cornerhouse.org

Ikon Staff

Arsha Arshad	Visitor Assistant
Simon Bloor	Visitor Assistant
Mike Buckle	Assistant – Ikon Shop
James Cangiano	Education Coordinator
Rosalind Case	PA/Office Manager
James Eaves	Fundraising Manager
Siân Evans	Programme Assistant
Richard George	Manager – Ikon Shop
Graham Halstead	Deputy Director
Matthew Hogan	Facilities Technician (AV/IT)
Saira Holmes	Curator (Education and Interpretation)
Deborah Kermode	Curator (Off-site)
Helen Legg	Curator (Off-site)
Emily Luxford	Marketing Assistant
Chris Maggs	Facilities Technician
Deborah Manning	Visitor Assistant
Jacklyn McDonald	Visitor Assistant
Natalia Morris	Visitor Assistant
Michelle Munn	Visitor Assistant
Esther Nightingale	Education Coordinator (Creative Partnerships)
Matt Nightingale	Gallery Facilities Manager
Melissa Nisbett	Marketing Manager
Jigisha Patel	PR and Press Manager
Nigel Prince	Curator (Gallery)
Theresa Radcliffe	Gallery Assistant
Kate Self	Gallery Assistant
Nikki Shaw	Education Coordinator
Richard Short	Technical and Office Assistant
Diana Stevenson	Exhibitions Coordinator
Dianne Tanner	Finance Manager
Jonathan Watkins	Director
Leon Yearwood	Visitor Assistant

IKON **GLYNN VIVIAN ART GALLERY**

ISBN 1 904864 19 8

Edited by Nigel Prince
Designed by James Langdon
Printed by Dexter Graphics

All photography and scans by Juneau Projects
except pages 42–43, 'I am swimming through
pools of cool water', Polly Braden

All images courtesy of the artists and fa
projects, London except 'Driving off the
spleen', courtesy of The Zabludowicz Art
Trust

'Walkman/Lake', 'Stalker', 'Pastoral ennui',
'Digital shy', 'Born in 82', 'Like waking
from a dream of incest feeling ruined
forever', 'Disc[0]', 'I am swimming through
pools of cool water', 'Ban this' and 'Juneau
records' commissioned by Grizedale Arts;

'A rich future is still ours' commissioned
as part of the hothaus series, Vivid,
Birmingham;

'Motherf⬤king Nature' commissioned by The
Showroom, London;

'Stag becomes eagle' commissioned by Thurrock
Council, Commissions East and the RSPB;

'Heart of an owl' commissioned by Compton
Verney House Trust;

'Antler fonts' commissioned by Sheffield
Contemporary Art Forum;

'Will I see another highway' commissioned by
Blackpool Museum of Contemporary Art